Academic

Preparation

In the Arts

Teaching for Transition
From High School
To College

College Entrance Examination Board, New York, 1985

Academic Preparation in the Arts is one of a series of six books. The Academic Preparation Series includes books in English, the Arts, Mathematics, Science, Social Studies, and Foreign Language. Single copies of any one of these books can be purchased for $6.95. Orders for 5 to 49 copies receive a 20% discount; orders for 50 or more receive a 50% discount.

A boxed set of all the books in the Academic Preparation Series is available for $20.00. Orders for five or more sets receive a 20% discount. Each set also includes a copy of *Academic Preparation for College: What Students Need to Know and Be Able to Do*.

Payment or purchase order for individual titles or the set should be addressed to: College Board Publications, Box 886, New York, New York 10101.

An excerpt from the poem "Adam's Curse," by W. B. Yeats, appearing on page 14, is reprinted with permission from *The Poems of W. B. Yeats*, edited by Richard J. Finneran (New York: Macmillan, 1983, page 80).

ISBN: 0-87447-221-0

9 8 7 6 5 4 3 2

Contents

To Our Fellow Teachers of the Arts *1*

I. **Beyond the Green Book**. *4*
Students at Risk, Nation at Risk *5*
The Classroom: At the Beginning as Well as the End of
 Improvement . *8*
From Deficit to Development *9*
Dimensions for a Continuing Dialogue *11*

II. **Preparation and Outcomes** *14*
Why Are the Arts among the Basic Academic Subjects? *14*
What Kind of Foundation? Arts Education before High School . *17*
What Are the Goals of Arts Education in the High School? . . . *20*
 Production and Performance Abilities *21*
 Analysis, Interpretation, and Evaluation *23*
 Historical and Cultural Knowledge *24*
Conclusion . *25*

III. **Courses in the Arts** *26*
Visual Arts . *27*
 Introduction to the Visual Arts: Two- and Three-Dimensional
 Design . *28*
 Introduction to the Visual Arts: Varied Media. *30*
 Theater . *31*
 Introduction to Theater *33*
 Acting and Directing. *34*
 Music . *35*
 Chorus. *36*
 Introduction to Music *38*
 Dance . *39*
 Dance Technique and Choreography. *40*
 Introduction to Dance *42*
Other Directions: Additional Patterns for Teaching the Arts in
 High School . *43*

Crossing Artistic Disciplines: A Course on Arts and Cultures . 44
Crossing Academic Disciplines: Music and Computer Science 45

IV. **Teaching the Arts** . 47
"I Can't Do It" . 48
An Argument Worth Watching 49
"What Are Those Kids Doing Here?" 52
Shirts and More Shirts 54
Blue Potato Chips 56
The Hedgehog and the Computer 59

V. **The Arts and the Basic Academic Competencies** 62
The Basic Academic Competencies 62
Reading . 62
Writing . 64
Speaking and Listening 66
Mathematics . 68
Reasoning . 69
Studying . 70
Other Basic Skills . 72
Observing . 72
Computer Competency 73
Conclusion . 74

VI. **Toward Further Discussion** 75
How to Achieve Excellence 75
Moving beyond Production and Performance 75
Whose Arts? . 75
Assessment . 76
Breadth versus Depth 77
The Arts and Other Subjects 78
The Use of Outside Artists and Arts Organizations 79
Issues beyond the Arts Classroom 80
Seeing Arts Courses as Basic 80
Overcoming the Vulnerability of Arts Programs 81
Conclusion . 85

Bibliography . 86

Members of the Council on Academic Affairs, 1983-85 . 92

Principal Writers and Consultants

Dennis Palmer Wolf, Research Associate, Harvard Graduate School of Education

Thomas Wolf, President, The Wolf Organization, Inc.

Arts Advisory Committee, 1984-85

David Greene, Wabash College, Crawfordsville, Indiana (*Chair*)

Elizabeth Weil Bergmann, Torrey Pines High School, Del Mar, California

Murry DePillars, Virginia Commonwealth University, Richmond

Marie Lerner-Sexton, Shawnee Mission South High School, Kansas

Barbara Nicholson, D.C. Commission on the Arts and Humanities, Washington, D.C.

Janice Silverman, Temple University, Philadelphia, Pennsylvania

Henry Wicke, Jr., Packer Collegiate Institute, Brooklyn, New York

Acknowledgments

The College Board wishes to thank all the individuals and organizations that contributed to *Academic Preparation in the Arts.* In addition to those who served on the Arts Advisory Committee and the Council on Academic Affairs, explicit acknowledgment should be accorded to Yola Coffeen, Robert Orrill, Mary Carroll Scott, and Carol J. Meyer. Without the leadership of Charles Dorn of Purdue University and Adrienne Y. Bailey, vice president for Academic Affairs at the College Board, this book would not have assumed its present form. Although none of these people is individually responsible for the contents of the book, the Educational EQuality Project owes much to their efforts.

James Herbert, General Editor

The College Board is a nonprofit membership organization that provides tests and other educational services for students, schools, and colleges. The membership is composed of more than 2,500 colleges, schools, school systems, and education associations. Representatives of the members serve on the Board of Trustees and advisory councils and committees that consider the College Board's programs and participate in the determination of its policies and activities.

The Educational EQuality Project is a 10-year effort of the College Board to strengthen the academic quality of secondary education and to ensure equality of opportunity for postsecondary education for all students. Begun in 1980, the project is under the direction of the Board's Office of Academic Affairs.

For more information about the Educational EQuality Project and inquiries about this report, write to the Office of Academic Affairs, The College Board, 45 Columbus Avenue, New York, New York 10023-6917.

To Our Fellow Teachers of the Arts

The appearance of the College Board's book *Academic Preparation for College: What Students Need to Know and Be Able to Do* had special meaning for us as teachers of the arts. In it we read that distinguished educators had recognized the importance of study in the arts to the high school curriculum. The Green Book, as it has since come to be called, listed the arts as one of the six Basic Academic Subjects that help prepare high school students for college. In addition, the book suggested that work in the arts can serve as one of the vehicles for equipping students with the Basic Academic Competencies required both for college and for lifelong learning—skills such as speaking and listening, reading, studying, reasoning, and observing.

As Chapter 1 explains, this book takes up where the Green Book left off. The task of Chapter 2 is to amplify the Green Book's statement of the goals of high school work in the arts done by prospective college students. Chapters 3 and 4 note some of the ways that teachers can and do help students move toward those goals. They indicate how thoughtful and innovative arts courses and classroom strategies make the arts come alive for students and contribute significantly to the excellence of their educational programs. Chapter 6 raises some of the questions faced by arts teachers as shrinking enrollments, tight budgets, and demands for academic excellence put pressures on school administrators and school board members. The book as a whole implicitly urges us to meet these challenges by reminding ourselves of the place of the arts in American high schools and taking stock of how far we have come in establishing that place.

Our journey has not been an easy one. The seriousness of our students' work has been questioned. We have had to listen to well-meaning people argue that "the arts are nice but. . . ." Usually the "but" has connected to a second statement about the school's need to focus its resources on "basic skill learning." While this book cannot eliminate the financial and administrative challenges to our

1

effectiveness, it can help us answer those individuals who are not convinced that the arts should be part of the high school curriculum. Simply stated, it holds both that the arts are a basic subject and also that course work in the arts, like courses in the other basic subjects, contributes to the development of the Basic Academic Competencies identified in the Green Book. Chapter 5 is devoted to delineating this contribution.

As arts teachers, we often occupy a special position with respect to our students. The art room, the auditorium, and the rehearsal studios are often regarded as "safe havens," places where school ends and enjoyment begins. With some students, that enjoyment turns into an almost passionate commitment to working creatively. For other students, it may take a less constructive form—a time for relaxation and socializing. Another of our great challenges in teaching the arts is to convince all students that the arts demand the same kind of serious study that is required in their other subjects. Chapters 3 and 4 suggest ways to think about this challenge.

Our more dedicated students present a different challenge. Many of them look to us as special mentors, as teachers who will give them a particularly intensive kind of attention, guidance, and encouragement. We know that this goes beyond what is normally expected of teachers, yet we want to respond. It is natural to want to encourage those who understand what we are trying to teach, who admire us, and who respect our career choices. But sometimes it seems that there are not enough hours in the school day to meet everyone's needs. We are torn between the desire to respond to the needs of these students and the requirement that we fulfill all the other demands on our time. For some of us, these demands may include our own need to perform and produce works of art.

If we sometimes become discouraged, we can take comfort in the fact that our own educational memories are often dominated by the special excitement of arts classes and the unique qualities of arts teachers. They, too, may have wished they could have spent more time with us. But regardless of what they were or were not able to do, they influenced our lives profoundly and, in many cases, convinced us to devote our lives to the arts. Passing along this influence may be what is so special about teaching in the arts, and it may be why so many of us have stayed in the profession when other opportunities beckoned.

In many ways, this is an idea book. It offers curricular ideas, teaching strategies, rationales for arts learning, and explorations of other, related issues. But, like many such books, this one can only skim the surface. It should raise as many questions as it answers and elicit disagreement as well as consensus. It will succeed to the extent that it generates dialogue and debate. It may, in addition, inspire arts teachers in high school to share their own special expertise with one another, with teachers in other subjects, with school administrators, with parents, and with everyone interested in quality education for all students.

Arts Advisory Committee

I. Beyond the Green Book

Identifying the academic preparation needed for college is a first step toward providing that preparation for all students who might aspire to higher education. But the real work of actually achieving these learning outcomes lies ahead.[1]

This book is a sequel to *Academic Preparation for College: What Students Need to Know and Be Able to Do,* which was published in 1983 by the College Board's Educational EQuality Project. Now widely known as the Green Book, *Academic Preparation for College* outlined the knowledge and skills students need in order to have a fair chance at succeeding in college. It summarized the combined judgments of hundreds of educators in every part of the country. The Green Book sketched learning outcomes that could serve as goals for high school curricula in six Basic Academic Subjects: English, the arts, mathematics, science, social studies, and foreign languages. It also identified six Basic Academic Competencies on which depend, and which are further developed by, work in these subjects. Those competencies are reading, writing, speaking and listening, mathematics, reasoning, and studying. The Green Book also called attention to additional competencies in using computers and observing, whose value to the college entrant increasingly is being appreciated.

With this book we take a step beyond *Academic Preparation for College.* The Green Book simply outlined desired results of high school education—the learning all students need to be adequately prepared for college. It contained no specific suggestions about how to achieve those results. Those of us working with the Educational EQuality Project strongly believed—and still believe—that ultimately curriculum and instruction are matters of local expertise

1. The College Board, *Academic Preparation for College: What Students Need to Know and Be Able to Do* (New York: The College Board, 1983), p. 31.

and responsibility. Building consensus on goals, while leaving flexible the means to achieve them, makes the most of educators' ability to respond appropriately and creatively to conditions in their own schools. Nevertheless, teachers and administrators, particularly those closely associated with the EQuality project, often have asked how the outcomes sketched in the Green Book might be translated into actual curricula and instructional practices—how they can get on with the "real work" of education. These requests in part seek suggestions about how the Green Book goals might be achieved; perhaps to an even greater extent they express a desire to get a fuller picture of those very briefly stated goals. Educators prefer to think realistically, in terms of courses and lessons. Discussion of proposals such as those in the Green Book proceeds more readily when goals are filled out and cast into the practical language of possible courses of action.

To respond to these requests for greater detail, and to encourage further nationwide discussion about what should be happening in our high school classrooms, teachers working with the Educational EQuality Project have prepared this book and five like it, one in each of the Basic Academic Subjects. By providing suggestions about how the outcomes described in *Academic Preparation for College* might be achieved, we hope to add more color and texture to the sketches in that earlier publication. We do not mean these suggestions to be prescriptive or definitive, but to spark more detailed discussion and ongoing dialogue among our fellow teachers who have the front-line responsibility for ensuring that all students are prepared adequately for college. We also intend this book and its companions for guidance counselors, principals, superintendents, and other officials who must understand the work of high school teachers if they are better to support and cooperate with them.

Students at Risk, Nation at Risk

Academic Preparation for College was the result of an extensive grassroots effort involving hundreds of educators in every part of the country. However, it was not published in a vacuum. Since the beginning of this decade, many blue-ribbon commissions and stud-

ies also have focused attention on secondary education. The concerns of these reports have been twofold. One, the reports note a perceptible decline in the academic attainments of students who graduate from high school, as indicated by such means as standardized test scores and comments from employers; two, the reports reflect a widespread worry that, unless students are better educated, our national welfare will be in jeopardy. *A Nation at Risk* made this point quite bluntly:

> Our Nation is at risk. Our once unchallenged preeminence in commerce, industry, science, and technological innovation is being overtaken by competitors throughout the world. . . . The educational foundations of our society are presently being eroded by a rising tide of mediocrity that threatens our very future as a Nation and a people.[2]

The Educational EQuality Project, an effort of the College Board throughout the decade of the 1980s to improve both the quality of preparation for college and the equality of access to it, sees another aspect of risk: if our nation is at risk because of the level of students' educational attainment, then we must be more concerned with those students who have been most at risk.

Overall, the predominance of the young in our society is ending. In 1981, as the EQuality project was getting under way, about 41 percent of our country's population was under 25 years old and 26 percent was 50 years old or older. By the year 2000, however, the balance will have shifted to 34 percent and 28 percent, respectively. But these figures do not tell the whole story, especially for those of us working in the schools. Among certain groups, youth is a growing segment of the population. For example, in 1981, 71 percent of black and 75 percent of Hispanic households had children 18 years old or younger. In comparison, only 52 percent of all white households had children in that age category. At the beginning of the 1980s, children from minority groups already made up more than 25 percent of all public school students.[3] Clearly, concern for im-

2. National Commission on Excellence in Education, *A Nation at Risk* (Washington, D.C.: U.S. Government Printing Office, 1983), p. 5.

3. Ernest L. Boyer, *High School* (New York: Harper & Row, 1983), pp. 4-5. U.S. Department of Education, National Center for Education Statistics, *Digest of Education Statistics: 1982* (Washington, D.C.: U.S. Government Printing Office, 1982), p. 43.

proving the educational attainments of all students increasingly must involve concern for students from such groups of historically disadvantaged Americans.

How well will such young people be educated? In a careful and thoughtful study of schools, John Goodlad found that "consistent with the findings of virtually every study that has considered the distribution of poor and minority students . . . minority students were found in disproportionately large percentages in the low track classes of the multiracial samples [of the schools studied]."[4] The teaching and learning that occur in many such courses can be disappointing in comparison to that occurring in other courses. Goodlad reported that in many such courses very little is expected, and very little is attempted.[5]

When such students are at risk, the nation itself is at risk, not only economically but morally. That is why this book and its five companions offer suggestions that will be useful in achieving academic excellence for *all* students. We have attempted to take into account that the resources of some high schools may be limited and that some beginning high school students may not be well prepared. We have tried to identify ways to keep open the option of preparing adequately for college as late as possible in the high school years. These books are intended for work with the broad spectrum of high school students—not just a few students and not only those currently in the "academic track." We are convinced that many more students can—and, in justice, should—profit from higher education and therefore from adequate academic preparation.

Moreover, many more students actually enroll in postsecondary education than currently follow the "academic track" in high school. Further, discussions with employers have emphasized that many of the same academic competencies needed by college-bound students also are needed by high school students going directly into the world of work. Consequently, the Educational EQuality Project, as its name indicates, hopes to contribute to achieving a democratic excellence in our high schools.

4. John Goodlad, *A Place Called School* (New York: McGraw-Hill, 1984), p. 156.

5. Ibid., p. 159.

The Classroom: At the Beginning as Well as the End of Improvement

A small book such as this one, intended only to stimulate dialogue about what happens in the classroom, cannot address all the problems of secondary education. On the other hand, we believe that teachers and the actual work of education—that is to say, curriculum and instruction—should be a more prominent part of the nationwide discussion about improving secondary education.

A 1984 report by the Education Commission of the States found that 44 states either had raised high school graduation requirements or had such changes pending. Twenty-seven states had enacted new policies dealing with instructional time, such as new extracurricular policies and reduced class sizes.[6] This activity reflects the momentum for and concern about reform that has been generated recently. It demonstrates a widespread recognition that critiques of education without concrete proposals for change will not serve the cause of improvement. But what will such changes actually mean in the classroom? New course requirements do not necessarily deal with the academic quality of the courses used to fulfill those requirements. Certain other kinds of requirements can force instruction to focus on the rote acquisition of information to the exclusion of fuller intellectual development. Manifestly, juggling of requirements and courses without attention to what needs to occur between teachers and students inside the classroom will not automatically produce better prepared students. One proponent of reform, Ernest Boyer, has noted that there is danger in the prevalence of "quick-fix" responses to the call for improvement. "The depth of discussion about the curriculum . . . has not led to a serious and creative look at the nature of the curriculum. . . . states [have not asked] what we ought to be teaching."[7]

6. *Action in the States: Progress toward Education Renewal*, A Report by the Task Force on Education for Economic Growth (Denver, Colorado: Education Commission of the States, 1984), p. 27.

7. In Thomas Toch, "For School Reform's Top Salesmen, It's Been Some Year," *Education Week*, June 6, 1984, p. 33.

Such questioning and discussion is overdue. Clearly, many improvements in secondary education require action outside the classroom and the school. Equally clearly, even this action should be geared to a richer, more developed understanding of what is needed in the classroom. By publishing these books we hope to add balance to the national debate about improving high school education. Our point is not only that it is what happens between teachers and students in the classroom that makes the difference. Our point is also that what teachers and students do in classrooms must be thoughtfully considered before many kinds of changes, even exterior changes, are made in the name of educational improvement.

From Deficit to Development

What we can do in the classroom is limited, of course, by other factors. Students must be there to benefit from what happens in class. Teachers know firsthand that far too many young people of high school age are no longer even enrolled. Nationally, the drop-out rate in 1980 among the high school population aged 14 to 34 was 13 percent. It was higher among low-income and minority students. Nearly 1 out of 10 high schools had a drop-out rate of over 20 percent.[8]

Even when students stay in high school, we know that they do not always have access to the academic preparation they need. Many do not take enough of the right kinds of courses. In 1980, in almost half of all high schools, a majority of the students in each of those schools was enrolled in the "general" curriculum. Nationwide, only 38 percent of high school seniors had been in an academic program; another 36 percent had been in a general program; and 24 percent had followed a vocational/technical track. Only 39 percent of these seniors had enrolled for three or more years in history or social studies; only 33 percent had taken three or more years of mathematics; barely 22 percent had taken three or more

8. National Center for Education Statistics, *Digest of Education Statistics: 1982*, p. 68. Donald A. Rock, et al., "Factors Associated with Test Score Decline: Briefing Paper" (Princeton, New Jersey: Educational Testing Service, December 1984), p. 4.

years of science; and less than 8 percent of these students had studied Spanish, French, or German for three or more years.[9]

Better than anyone else, teachers know that, even when students are in high school and are enrolled in the needed academic courses, they must attend class regularly. Yet some school systems report daily absence rates as high as 20 percent. When 1 out of 5 students enrolled in a course is not actually there, it is difficult even to begin carrying out a sustained, coherent program of academic preparation.

As teachers we know that such problems cannot be solved solely by our efforts in the classroom. In a world of disrupted family and community structures; economic hardship; and rising teenage pregnancy, alcoholism, and suicide, it would be foolish to believe that attention to curriculum and instruction can remedy all the problems leading to students' leaving high school, taking the wrong courses, and missing classes. Nonetheless, what happens in the high school classroom—once students are there—is important in preparing students not only for further education but for life.

Moreover, as teachers, we also hope that what happens in the classroom at least can help students stick with their academic work. Students may be increasingly receptive to this view. In 1980 more than 70 percent of high school seniors wanted greater academic emphasis in their schools; this was true of students in all curricula. Mortimer Adler may have described a great opportunity:

> There is little joy in most of the learning they [students] are now compelled to do. Too much of it is make-believe, in which neither teacher nor pupil can take a lively interest. Without some joy in learning—a joy that arises from hard work well done and from the participation of one's mind in a common task—basic schooling cannot initiate the young into the life of learning, let alone give them the skill and the incentive to engage in it further.[10]

Genuine academic work can contribute to student motivation and persistence. Goodlad's study argues strongly that the widespread focus on the rote mechanics of a subject is a surefire way to distance

9. National Center for Education Statistics, *Digest of Education Statistics: 1982*, p. 70.

10. Mortimer J. Adler, *The Paideia Proposal: An Educational Manifesto* (New York: Macmillan Publishing Company, 1982), p. 32.

students from it or to ensure that they do not comprehend all that they are capable of understanding. Students need to be encouraged to become inquiring, involved learners. It is worth trying to find more and better ways to engage them actively in the learning process, to build on their strengths and enthusiasms. Consequently, the approaches suggested in these books try to shift attention from chronicling what students do not know toward developing the full intellectual attainments of which they are capable and which they will need in college.

Dimensions for a Continuing Dialogue

This book and its five companions were prepared during 1984 and 1985 under the aegis of the College Board's Academic Advisory Committees. Although each committee focused on the particular issues facing its subject, the committees had common purposes and common approaches. Those purposes and approaches may help give shape to the discussion that this book and its companions hope to stimulate.

Each committee sought the assistance of distinguished writers and consultants. The committees considered suggestions made in the dialogues that preceded and contributed to *Academic Preparation for College* and called on guest colleagues for further suggestions and insights. Each committee tried to take account of the best available thinking and research but did not merely pass along the results of research or experience. Each deliberated about those findings and then tried to suggest approaches that had actually worked to achieve learning outcomes described in *Academic Preparation for College*. The suggestions in these books are based to a great extent on actual, successful high school programs.

These books focus not only on achieving the outcomes for a particular subject described in the Green Book but also on how study of that subject can develop the Basic Academic Competencies. The learning special to each subject has a central role to play in preparing students for successful work in college. That role ought not to be neglected in a rush to equip students with more general skills. It is learning in a subject that can engage a student's interest, activity, and commitment. Students do, after all, read about *some-*

thing, write about *something,* reason about *something.* We thought it important to suggest that developing the Basic Academic Competencies does not replace, but can result from, mastering the unique knowledge and skills of each Basic Academic Subject. Students, particularly hungry and undernourished ones, should not be asked to master the use of the fork, knife, and spoon without being served an appetizing, full, and nourishing meal.

In preparing the book for each subject, we also tried to keep in mind the connections among the Basic Academic Subjects. For example, the teaching of English and the other languages should build on students' natural linguistic appetite and development—and this lesson may apply to the teaching of other subjects as well. The teaching of history with emphasis on the full range of human experience, as approached through both social and global history, bears on the issue of broadening the "canon" of respected works in literature and the arts. The teaching of social studies, like the teaching of science, involves mathematics not only as a tool but as a mode of thought. There is much more to make explicit and to explore in such connections among the Basic Academic Subjects. Teachers may teach in separate departments, but students' thought is probably not divided in the same way.

Finally, the suggestions advanced here generally identify alternate ways of working toward the same outcomes. We wanted very much to avoid any hint that there is one and only one way to achieve the outcomes described in *Academic Preparation for College.* There are many good ways of achieving the desired results, each one good in its own way and in particular circumstances. By describing alternate approaches, we hope to encourage readers of this book to analyze and recombine alternatives and to create the most appropriate and effective approaches, given their own particular situations.

We think that this book and its five companion volumes can be useful to many people. Individual teachers may discover suggestions that will spur their own thought about what might be done in the classroom; small groups of teachers may find the book useful in reconsidering the arts program in their high school. It also may provide a takeoff point for in-service sessions. Teachers in several subjects might use it and its companions to explore concerns, such as the Basic Academic Competencies, that range across the

high school curriculum. Principals may find these volumes useful in refreshing the knowledge and understanding on which their own instructional leadership is based.

We also hope that these books will prove useful to committees of teachers and officials in local school districts and at the state level who are examining the high school curriculum established in their jurisdictions. Public officials whose decisions directly or indirectly affect the conditions under which teaching and learning occur may find in the books an instructive glimpse of the kinds of things that should be made possible in the classroom.

Colleges and universities may find in all six books occasion to consider not only how they are preparing future teachers, but also whether their own curricula will be suited to students receiving the kinds of preparation these books suggest. But our greatest hope is that this book and its companions will be used as reference points for dialogues between high school and college teachers. It was from such dialogues that *Academic Preparation for College* emerged. We believe that further discussions of this sort can provide a wellspring of insight and energy to move beyond the Green Book toward actually providing the knowledge and skills all students need to be successful in college.

We understand the limitations of the suggestions presented here. Concerning what happens in the classroom, many teachers, researchers, and professional associations can speak with far greater depth and detail than is possible in the pages that follow. This book aspires only to get that conversation going, particularly across the boundaries that usually divide those concerned about education, and especially as it concerns the students who often are least well served. Curriculum, teaching, and learning are far too central to be omitted from the discussion about improving education.

II. Preparation and Outcomes

Why Are the Arts among the Basic Academic Subjects?

What are the reasons that the arts are becoming and have become a part of the high school core curriculum? The poet W. B. Yeats was close to an answer when he wrote:

> Better go down upon your marrow bones
> And scrub kitchen pavement or break stones
> Like an old pauper, in all kinds of weather;
> For to articulate sweet sounds together
> Is to work harder than all these. . . .[1]

Indeed, the arts engage individuals in "hard work." First, there is the hard work of a kind of knowing that is distinctive to the arts and the hard work of learning a set of skills that fit this special kind of knowing.

- The arts and the courses that deal with them train students to apprehend and value the qualitative dimension of life. Becoming attentive to the unique qualities that make every object and each aspect of life peculiarly itself leads to a kind of knowing that is crucial for us. This kind of knowing is the special domain of the arts. In making artworks and giving close attention to those of others, students learn to hear the texture of sound, to see the play of light and shadow, to notice the smoothness or jaggedness of motion, to attend to the intensity of dramatic resolution.

- In becoming more sensitive to the unique qualities of a work of art, students also become alert to the qualitative dimension of life in general. They feel the need to create or perform works that embody these qualities and in doing so to clarify, celebrate,

1. William Butler Yeats, "Adam's Curse," in *The Poems of W. B. Yeats*, ed. by Richard J. Finneran (New York: Macmillan, 1983), p. 80.

and share them. Arts courses are designed to this end: in them students learn techniques and begin to control materials so that they can make objects or perform works of this kind.

- The process as a whole helps students to understand themselves, others, and fundamental human issues. By attending to the qualitative dimension of life and practicing artistic skills in pursuit of this dimension, students discover that they can express a wider range of experience and better convey the vividness of the experience than they can in everyday communication. This work is liberating and liberalizing, so it is a joy as well as hard work. In making a photograph, composing a song, or performing a scene students have the opportunity to express personal insights or otherwise fleeting emotions. By seeing a dance or drama that vividly portrays a different situation, time, or culture students often begin to take a keen interest in understanding lives other than their own. Moreover, by becoming immersed in the works of other periods and cultures, students have a chance to discover the universal human interest in going beyond what is necessary for bare survival by capturing or creating qualities that are pleasing, beautiful, monumental, or extraordinary. They confront the great artist's challenges to what he or she believes to be shabby or pretentious or unjust.

- Work in the arts stimulates the imagination. It prods students to learn what "working the imagination" means. Composing a piece of music or a short dance, finding a metaphor, laying out a drawing—all demand invention. When a student interprets a character in a play, works out the phrasing for an instrumental piece, or contributes ideas in a dance rehearsal, invention is involved. In pursuing their imaginative grasp on the qualitative dimension of life, students come to recognize the importance of moving beyond initial concepts and first drafts by the hard work of rehearsing, revising, and refining. In studying artworks that have stood the test of time, students discover the visions of wholeness and the greater worlds created by humanity's most profound imaginations.

Second, there is the hard work of developing a number of skills and competencies that are common to the full range of academic work.

- As performers, students must improve their ability to read scores or texts, to listen to instructions, and to learn from other performers, and they must learn to practice all these skills at the same time. In producing a play, students have to discover the ideas and viewpoint of the playwright by reading the script. Then they must develop their theatrical ideas and translate them into gestures, movements, and speech in order to convey them to other actors, the director, and eventually the audience. Finally, they have to collaborate with other students who are working on lights, costumes, and scenery. Thus, performances involve students in an activity that has many complexly interrelated parts and that requires long-term planning and group processes.

- Arts courses ask students to analyze, interpret, and evaluate artworks and to study the works' history and cultural roots. This study challenges and develops their analytic and observational skills. Serious understanding of a dance or film requires the ability to "read" on a number of levels and to integrate basic observations into broader interpretations. Understanding a piece of music or a painting involves grasping what the artist achieved with the particular materials: seeing the balance and tension in the composition; reading the images and symbols; and finding what is pleasing, innovative, or surprising. Evaluating artworks involves students in the challenging processes of making comparisons, inquiring into the differences between personal taste and artistic value, and being able to discuss their evaluations with other people who may or may not agree. All these abilities are stretched and broadened when students apply them to works from a variety of cultures and times.

These two kinds of "hard work" do not happen spontaneously—as is sometimes assumed. Exactly like foreign language skills or mathematics skills, artistic skills cannot be acquired without training. The arts must be treated as one of the six Basic Academic Subjects, because without intensive, carefully designed instruction few students can grow in artistic knowledge, skill, or imagination. Moreover, where the arts are not taught in school, study of the arts becomes a privilege belonging to the few students whose extraordinary talent calls attention to them or whose families value the arts highly.

Ignorance of art is a form of illiteracy. Whether or not they intend to pursue the arts as college students or as professional artists, students need the special kind of knowing that makes work in the arts distinctive. Moreover, well-designed work in the arts can contribute to the students' acquisition of Basic Academic Competencies and enrich what they are learning in the other five Basic Academic Subjects. For example, learning in the arts may nurture the students' willingness to be innovative. It may train them to be flexible in their approaches to problem solving, develop their capacities for sustaining their commitment to long-term projects, and enhance their ability to learn from others. The close examination of artworks may reinforce observational and interpretative skills akin to those used in the physical and social sciences. Appreciation of the arts is integral to the understanding of other cultures and periods that is sought in history, foreign language, and social science courses. And, of course, students who are deeply interested in the arts or whose greatest talents lie there deserve opportunities for serious preparation.

This description of the distinctive contributions that training in the arts can make to students' academic development will be elaborated by the rest of the chapter. The next section lists the kinds of skills that signal that beginning high school students have acquired an initial understanding of the distinctive lessons the arts teach about quality, imagination, and human issues. The last section identifies in more detail the precise nature of the needed results of high school work in the arts described in *Academic Preparation for College*. Chapter 5 is intended to help arts teachers think about how their courses, in addition to teaching the arts' special way of knowing, may also contribute to students' mastery of the Basic Academic Competencies identified by the Green Book—reading, writing, speaking and listening, mathematics, reasoning, and studying, as well as competency in observing and the use of computers.

What Kind of Foundation?
Arts Education before High School

To be ready for serious high school work in the arts, students must have some prior preparation. Unfortunately, at the present time,

children's access to continuous and sequential artistic training in the arts varies widely during their elementary and junior high school years, depending on the resources of their schools and their families. On the one hand, high school teachers cannot assume that all their entering students have formal knowledge of the arts. On the other hand, many children have informally developed a set of abilities that do provide a foundation for secondary-level study of the arts. These abilities often include the following.

- *The ability to express meaning in various materials and symbol systems.* Between the ages of 5 and 12 many children become fluent users of oral language, movement, drawing, three-dimensional forms (clay, blocks, etc.), or vocal music. By age 12 many children are able to make an original work or put on a short performance (tell or write an anecdote, do an improvisation, draw an object or scene, sing a familiar song). It is likely, too, that they have a sense for the differences among symbol systems and media, even if they cannot explain these differences verbally. For example, in making an illustrated book, a student might describe a character's intentions in the text, while intuitively using the pictures to capture the influence of the concrete setting on these motives. In singing, as in contrast to speaking, a student might let pitch and rhythm come to the fore without self-consciously knowing that this is happening or why.

- *An initial understanding of the nonliteral nature of the arts.* Junior high school students usually are able to notice some of the expressive and figurative aspects of artworks. They probably can respond to expressive use of forms and shapes in the visual arts; sound qualities in music; postures, motions, and gestures in dances. In addition, students generally understand simple kinds of figurative meaning (for example, why a dancer in a North American Indian ritual might wear a crow mask, how sounds can be used to evoke moods in music, and why a writer might talk about the sky as silky).

- *A beginning appreciation of pattern or structure.* At the outset of high school, many students are not able to see compositional aspects of artworks very clearly. They can usually hear that a motif comes back in a song, see that certain movements recur

in a dance, point out when a play moves to a climax, and notice that a particular print uses certain colors and not others.

- *The ability to appraise and improve one's own work.* This skill is essential to the production of finished works or performances. It requires that students be able to stand back and assess their own work. The ability to monitor, edit, and redraft works or performances is usually only rudimentary in students entering high school. But they may well be able to improve a dramatic monologue by changing individual words or phrases; they may be able to compare and choose between two renditions of a phrase in a song or dance; and they may recognize that one drawing is more successful than another.

- *An understanding that the arts depend on individuals' going beyond formulas or imitations and that invention, humor, fantasy, and experiment are essential in artworks.* On entering high school, students are usually willing to go beyond what is routine and familiar. Consequently, in playing a role, a student may be able to imagine his or her way into a character, inventing gestures, facial expressions, and voice tones. Given charcoal, a student probably can explore different line qualities in drawings. When playing a clarinet, a young instrumentalist may try for both shrill and liquid sounds.

It is only realistic to recognize that students possess individualized profiles of artistic skills and exhibit them in quite different ways. Some students may excel in one arts discipline, yet lack either the basic skills or aptitude for a second art form. Students also vary widely in the particular ways in which they exhibit their current understandings of an artistic discipline. Some may be able to discuss or write about their understanding of the arts. Others are able to express their understanding only in their own work. Finally, some students may have had considerable formal training and exposure to the arts, while others may have had no opportunity to encounter, much less to study, works of art. Therefore, in designing high school arts courses and placing students in those classes, teachers must realize the need for a means to distinguish between achievement and aptitude in the arts, for a range of different experiences, and for a balance between verbal and nonverbal approaches to teaching and assessment.

19

What Are the Goals of Arts Education in the High School?

Arts education in American high schools is extremely varied. In some locations special high schools have been established to offer focused training in the arts. By contrast, many high schools do not require or offer sequential courses in the arts. Some students take as little as one credit in the arts; a few take none at all. In settings in which the arts are not offered as part of a required curriculum, students may be forced to pursue them in the framework of elective activities or in programs outside the school. Moreover, though most high schools do include some arts courses in the formal curriculum, schools vary in the resources that they dedicate to an arts program.

This variety in opportunities makes it problematic to specify the level of learning that should be acquired in each artistic discipline. However, it is possible to describe several types of artistic knowledge, as well as some basic skills and concepts that students should acquire during their high school years, regardless of the particular art discipline that they pursue.

To achieve the skills and knowledge described in *Academic Preparation for College*, students need the following.

- Intensive work in at least one art discipline, such as visual arts, theater, music, or dance. Students need time and in-depth instruction in order to focus on the unique concepts and ways of thinking that are specific to an art form.

- Significant progress toward three kinds of abilities.
 1. Knowledge of how to produce or perform works of art.
 2. Knowledge of how to analyze, interpret, and evaluate artworks.
 3. Knowledge of artworks of other periods and cultures and their contexts.

It is important that students do work in all three areas. Unbalanced emphasis on any one area leaves students without the full complement of skills that are important for understanding and enjoying the arts, and the distinctive contribution of arts courses to students' development is stunted.

Production and Performance Abilities

Effective high school arts education should provide students with opportunities to draft, execute, and refine original works or performances. The point of these experiences obviously cannot be to achieve professional quality. Instead, these experiences should offer students the chance to develop and improve the following skills.

- *The ability to use the techniques, media, tools, and processes characteristic of an art form.* For example, a student learning print making must master the basic skills involved in block cutting or plate design, inking, and printing. Band students should have the chance to improve their instrumental technique, their ability to read music, their ensemble playing, and their ability to follow a conductor's directions. As their technique progresses, arts students also feel their limitations more keenly, and their appreciation of professionals' abilities becomes more lively.

- *The ability to create one's own work or carry out a fresh performance of an existing score or text.* Work in the arts asks for more than technical expertise. There must also be inventiveness linked to a willingness to invest oneself in what one is doing. It is not enough for a dance student to be able to warm up and then execute a series of learned moves on command. He or she must also be able to improvise or to observe movement patterns and then compose these thematic materials into a coherent piece of choreography. Similarly, theater students ought to be encouraged to develop their portrayal of a character by experimenting with gestures, intonations, and motions.

- *The ability to draw on basic aesthetic concepts when creating or performing works.* High school students can be challenged to think about artistic concepts such as composition, expression, genre, form, style, and symbolic meanings. They can learn to define these terms and discuss works that exemplify them. Learning these concepts enriches their appreciation of other people's work and gives them a way to think about their own performances and productions. Thus, in producing a portfolio of photographic portraits, a student should be urged to think about the relations

21

of forms within the frame; to deal with the ways in which lighting, paper, and developing processes might create particular effects; and to draw ideas from other traditions such as Renaissance donor portraits, folk art, or portraits by photographers such as Avedon, Karsh, or Parks.

In addition, each of the arts focuses on particular symbol systems or problems that give it a unique character: the creation of three-dimensional forms distinguishes sculpture; the invention and performance of sustained, expressive movement through time is central in dance. An appreciation of these qualities is important if students are to appraise their own works or to recognize the problems, innovations, and achievements in works and performances by others.

■ *The ability to develop a concept or feeling by being attentive to oneself and one's world.* High school students are active, reflective observers of their own inner lives and the events around them. Arts teachers can help students forge a connection between such personal knowledge and creation or performance. Students need to be challenged to find problems or themes on their own.

Students will also benefit from the opportunity to study this process in the work of professional artists. They might examine the many studies that Picasso made for his *Guernica,* discuss the feelings brought out by war and death, and think about the difficult process of embodying such feelings in a work or performance.

■ *The ability to carry a work or performance through several stages of development.* A work or performance undergoes several phases of development: idea, initial sketch, first rehearsal or first-draft execution, and revision in the light of personal appraisal or criticism. Students need to learn to sustain their commitment to their project through this long arc. For instance, in preparing a monologue for performance, a theater student should be able to develop an overall concept for the piece, refine that concept through rehearsal and discussion and, finally, polish the work or performance using criticism from peers and teachers.

Analysis, Interpretation, and Evaluation

High school arts teachers should also show students how to engage in close and active examination of works and performances. The ability to study and appraise art involves the following skills.

- *The ability to examine a performance or work at a number of levels or from a range of vantage points.* Performances and works of art are dense—they have a number of aspects and convey their point or message at a number of levels, using a variety of techniques. Students must be alert to the details of a work or performance and move from these details to an understanding of its composition, expressive qualities, style, meaning, or ideas. For instance, understanding a performance of Alvin Ailey's "Revelations" requires that a student see several aspects at once: the form or pattern of the dance, the particular style of choreography, the manner in which the dancers perform the movements, the possible meanings implied by the character roles within the dance, and the way in which the piece builds on religious themes and music. It is only on the basis of such close acquaintance from several perspectives that students are ready to move on to evaluation and criticism.

- *The ability to evaluate a work of art or performance.* The process of evaluating works and performances can provide worthwhile experience in reflection, discussion, and reasoning. When this is the case, students have learned to distinguish between voicing their personal opinions and critically judging what they see and hear. They learn to evaluate their own strong, immediate reactions and to discriminate between impressions that are likely to interest others and those that are idiosyncratic. By talking with skilled viewers and listeners they come to see how other people move from personal impressions to critical opinions. While high school students do not have the historical background and aesthetic experience to act as full-fledged critics, they can learn to appraise their own works, participate in critiques in class, and talk with peers and teachers about their reactions to exhibits, concerts, and performances. For example, a high school student

might compare two versions of a poem he or she wrote, or write a review comparing the performances of two pieces in a school concert. Throughout this process, students also can learn to differentiate among personal taste, specific cultural values, and long-lasting and widely held values in judging the excellence of an artwork.

Historical and Cultural Knowledge

The arts program makes a major contribution to the high school curriculum when it introduces students to forms and styles of artistic work different from those they usually encounter.

Exposure to the arts of other periods and cultures expands students' understanding of the materials, forms, and themes available to them as artists or audience members. Moreover, the arts provide an approach to understanding concretely both the profound similarities and the distinctiveness of human lives in different periods and cultures. The ability to analyze artworks from historical and cultural vantage points includes the following skills.

- *The ability to understand and appreciate different artistic styles and works from representative historical periods and cultures.* The development of sensitivity to style requires close and informed examination of artworks. Students must learn how to recognize different types of artistic compositions and genres, distinctive kinds of materials and techniques, and varying motivations or purposes for performances or works. Students should be able to use their knowledge of style and period to deepen their understanding of actual works. For example, what does it add to know that *Hamlet* was written in Elizabethan times? What does knowing about Cubism and about Eskimo and African mask forms contribute to looking at a Braque painting? How did their Hispanic background affect the way muralists such as Orozco and Rivera painted?

- *The ability to appreciate how people of various cultures have used the arts to express themselves.* A study of works from different periods, cultures, and geographic locations can help students analyze various social, economic, intellectual, and psychological characteristics of time and place. For example, a comparison of

landscapes from different periods and places can reveal different cultural values and living patterns. Comparing twentieth-century dances (for example, the twist or break dancing) with nineteenth-century reels and waltzes can help students gain perspective on the forces shaping their own lives.

▪ *The ability to understand the social and intellectual influence affecting artistic forms.* Although the arts are a unique domain of human activity, works and performances are influenced by and produce influences in the wider context of human activity. Students should begin to understand examples of these mutual influences. For instance, they might examine the way that nineteenth-century commerce made Europeans and Americans more aware of Asian and African cultures, religions, values, and art and how these contacts affected Western concepts of visual composition and musical tonality in the late nineteenth century. Theater students could investigate the kind of theater that was popular on Broadway in the 1940s to see how it expressed the era's artistic and social values. Students should also have the chance to consider the way that contemporary works and performances, including their own, reflect cultural, political, and social issues.

Conclusion

The arts are distinct fields of study: they deal with different materials and problems and have different methods and purposes from mathematics, languages, science, or social studies. Consequently, the study of the arts can make a distinctive contribution to high school students' development. When this study includes all three components just described—making or performing artworks, learning to analyze and evaluate art, and knowing artworks of various periods and cultures—then it can teach students to understand and pursue quality, to be expressive and responsive, to exercise their imaginations, and to be interested in the visions and inventions of others. The challenge for teachers of the arts is to keep the eyes of students open to these many possibilities and help them develop the special knowledge, sensitivity, and skills that training in the arts offers.

25

III. Courses in the Arts

This chapter offers several examples of arts courses, all of them drawn from actual cases, and each providing a rich variety of arts learning. The courses described here are merely samples, not prescriptions, presented in order to generate ideas and discussions. There are literally hundreds of successful arts courses in American high schools, and only a few can be described in this short book. The selected courses have been chosen because they highlight the ways in which—even if a student can take only a single course—that course can work effectively toward all three of the goals of arts education that have been described in Chapter 2: production and performance skills, abilities in analysis and evaluation, and knowledge of the cultural contexts for and historical development of the art form. These courses also offer experiences that help develop the Basic Academic Competencies.

In the sections that follow, four arts disciplines will be discussed in detail—the visual arts, theater, music, and dance. Each section outlines specific skills and knowledge that college entrants need in the particular arts discipline, no matter what their prospective major may be. Then the section describes two sample courses that meet these needs, although obviously, if students are able to take more arts courses as part of a coherent program, they will make more progress toward meeting these needs. It is hoped that teachers can use this material as a springboard for innovative planning.

Each course described in this chapter has ambitious but realistic goals. To accomplish them, adequate time and appropriate scheduling are necessary. In most cases, an arts course requires approximately the same number of hours as a laboratory science course. In addition, most arts courses can benefit from schedules that permit special activities such as practicing, rehearsing, or studio work to take place during free periods or after school hours. While it is recognized that time is never unlimited and that not all schools

can provide access to buildings and faculty outside regular school hours, it is important to emphasize that serious study of the arts demands a major time commitment from students and faculty.

This chapter ends with some additional suggestions for teachers who want to consider possible courses that might build bridges between the arts or to other areas of the curriculum.

Visual Arts

The Green Book lists the following skills and kinds of knowledge as those that are needed by college entrants when their preparation in the arts is in the area of the visual arts.

- The ability to identify and describe—using the appropriate vocabulary—various visual art forms from different historical periods.
- The ability to analyze the structure of a work of visual art.
- The ability to evaluate a work of visual art.
- To know how to express themselves in one or more of the visual art forms, such as drawing, painting, photography, weaving, ceramics, and sculpture.

Teachers in the visual arts are faced with at least two major challenges. First, the visual arts include a tremendous range of media and activities. Choosing among these can be difficult, particularly since teachers want their students to experience the full range of art forms and know the basics of every medium—drawing, painting, print making, collage, sculpture, ceramics, weaving, jewelry making, leather working, photography, and film making. The challenge is to combine this desire with a concern for the greater depth and mastery that come with focused attention on a smaller number of media. Unless choices are made (and it is hard to make them), students may not receive sufficient depth of instruction in any one medium to allow for serious study, practice, learning, and retention.

The second challenge is to achieve a balance between learning in the arts and learning about them. Learning various studio techniques and making artworks are so absorbing and rewarding that

teachers and students are tempted to focus solely on *doing* art rather than also learning its history, how to observe critically, and how to make valid analyses and interpretations. This temptation is all the stronger because students sometimes sign up for an art class precisely because it is different from more conventional academic subjects. They are eager for the direct experience of putting brush to paper or molding clay between their fingers. The self-expression that hands-on work promotes is both important and joyful. The challenge is to combine the productive experience with a firm foundation in technical skills, analytic abilities, and historical knowledge so that the student's enthusiasm may be channeled into an even richer learning experience.

Introduction to the Visual Arts: Two- and Three-Dimensional Design

This is a full-year course. Its objective is to introduce students to all the elements of design: line, texture, value, shape, and color. Reflecting the concern for a balance of learning experiences, the course uses three approaches: students learn through creating their own work; they learn through class critiques of their work and that of their peers; and they learn through the study of historical models.

The course has been designed to accommodate the special demands of studio work. It has two double-period meetings a week. These longer periods allow students to work in a concentrated fashion, minimizing time spent in setup and cleanup. They are also encouraged to work on their projects after school or in free periods.

The course begins with a study of line through contour drawing. Using simple tools such as pencils, pens, or charcoal, students start by drawing figures. In order to learn eye–hand coordination, they are given exercises in which they are told to look only at the model they are drawing, not at the paper. A second project asks them to create illusions of space using only straight lines. A third asks them to vary the thickness of lines and, by use of the stroke and density of the line, create different textures.

After attempting to solve each of these problems, students display their work. The class discusses all the works and tries to

understand why one is more successful in solving a design problem than another. This exercise is augmented by the study of significant works from art history—drawings by Leonardo da Vinci, Ingres, Picasso, and Matisse; medieval woodcuts; Chinese landscape paintings; African batiks; and the paintings of Mondrian. From these models, students learn a variety of the ways that artists have worked with line.

The second segment of the course offers similar exercises for value and shape. Students learn to create volume by shading. They begin with geometric shapes drawn from familiar objects and move into simple still lifes. They use their hands to think about redesigning their own environments. The instructor integrates the development of historical knowledge and analytic-evaluative skills into this phase of the course by leading the students in discussions of drapery shading in early Renaissance paintings, shaded columns and spheres in works by David, and the illusion of light and shadow in Dürer engravings. Later, they move on to elements of composition, learning how to select a point of view for a drawing. They draw a still life from three different angles, framing it in different ways each time. They study the works of selected Cubist painters or Egyptian murals, learning what it means to have multiple points of view in the same composition.

Similar groups of exercises and learning activities center around studies of color and three-dimensionality. Students learn to mix colors, beginning with shades of gray and moving into exercises with primary and complementary colors. They match color swatches from magazines, keeping a diary of how certain shades and tints were achieved. They compare works of Giotto, Caravaggio, Rembrandt, Monet, El Greco, Van Gogh, Gauguin, Albers, and Motherwell in order to learn concepts such as warmth, chiaroscuro, and vibrating color. Exercises in three-dimensionality center on additive and subtractive sculpture (using soft stone, fire brick, plaster, and wax), studies of local architecture, positive and negative space, and the relationship of light and three-dimensionality.

Students are evaluated on their studio work, written papers, and tests. They benefit from writing one paper during each segment of the course; in these papers they analyze artworks of various periods with respect to the specific design elements that are the focus of

that segment's studio activities. The quizzes test the students' grasp of concept and vocabulary. Field trips to museums and visits by working artists also enrich the course.

Introduction to the Visual Arts: Varied Media

This course introduces students to seven very different media: ceramics, weaving, architecture, drawing, painting, print making, and photography. Its intent is not only to familiarize students with the techniques and materials of these media but to help them understand the way that culture and historical variation shape the way a particular medium is used. The topical headings of the course are five human needs: food, clothing, shelter, communication and expression, and technology. In addition to examinations, students are assigned studio projects and papers involving out-of-class research. Field trips to museums in order to see original works of art are also extremely valuable.

The course begins with discussions of how the art of a culture allows us to understand that culture better. An initial assignment asks students to select two works of art from different periods and to speculate about their cultural contexts using *only* the works themselves as a guide. Students show photographs of their artworks to each other and offer their hypotheses. Their peers attempt to discover additional clues from close examination of the works.

The course then takes up its first major topic: food. Students examine various kinds of eating utensils from different periods. They analyze them from the point of view of function and decoration, discussing the difference between everyday uses and ritual uses. They learn about the living patterns and beliefs of specific cultures by analyzing these objects. Then, working in clay, students make and decorate a pot, plate, or vessel, which they are to imagine that they have located in an archeological dig. Their peers attempt to describe the culture in which this utensil would have been appropriate.

A similar assignment centers around clothing. Looking at clothes worn by Eskimos, American prairie Indians, Puritans, and contemporary movie stars, they assess the influence of climate, religion,

and culture on clothes. They are asked to keep a notebook of magazine clippings around a theme: ritual clothing, confining clothing, or functional clothing. Subsequently, students must design and execute a resist dye (batik). In each assignment, there is a discussion of how *aesthetic* aspects complement functional ones. This discussion is crucial in order to distinguish the course from a social science approach to food and clothing. It is during these discussions that students learn and practice, in a rudimentary way, the elements of aesthetic analysis, interpretation, and evaluation.

In the unit on architecture, students work together to draw a ground plan for a city after studying nomadic tent life, villages of mud huts, medieval churches as religious centers, Renaissance palaces glorifying individual families, and the modern skyscraper as a center for commerce. The unit on communication and expression deals with the themes of war, death, religion, and motherhood as treated in two-dimensional art (painting, drawing, print making) over the centuries. The students also execute their own examples in the medium of their choice and offer critiques of one another's work.

The final unit, technology, looks at the development of photography. Studying the photographs of Brassai, Lartigue, Stieglitz, Käsebier, Weston, Adams, Polk, and Van Der Zee, students learn about the medium from a technological point of view, trying simple photographic experiments of their own (with pin-hole or Polaroid cameras). They also learn how the medium has advanced technologically and how these advances have enabled it to become an art form expressive of specific eras, locations, and cultural concerns.

Theater

According to the Green Book, when the arts preparation of college entrants is in theater, they will need the following knowledge and skills.

- The ability to identify and describe—using the appropriate vocabulary—different kinds of plays from different historical periods.

- The ability to analyze the structure, plot, characterization, and language of a play, both as a literary document and as a theater production.
- The ability to evaluate a theater production.
- To know how to express themselves by acting in a play or by improvising, or by writing a play, or by directing or working behind the scenes of a theater production.

Theater is a performing art that uses words and texts as a principal form of expression and communication. As a result, many of the skills that students must acquire are closely related to skills taught in English classes—reading, writing, speaking, listening. This offers both challenges and opportunities. Teachers of theater can build on the various learning activities from students' English classes. In particular, they will find the following abilities, developed in English classes, particularly useful for students in theater.

- Reading texts critically and analytically, recognizing assumptions and implications, and evaluating ideas.
- Reading and understanding a range of literature representing different cultures and traditions.
- Responding actively and imaginatively to literature and engaging in discussion, interpreting, analyzing, and summarizing.
- Recognizing the intention of a speaker or a writer and being aware of the techniques used to affect an audience.

Yet teachers of theater have the special responsibility of going beyond the kind of textual analysis that occurs in English classes. They can alert their students to the expressive content of *spoken* words and can offer them experience in developing interpretations of characters and situations through movement. They can challenge their students to explore the unique properties of gestures and facial expression as well as the special devices of the theater—scenery, costumes, lighting effects—in attempting to communicate to an audience.

Just as in the other arts, teachers of theater must find the appropriate balance of analysis and evaluation, historical study, and productive and performance elements, as described in Chapter 2.

The curricular examples that follow suggest how that balance can be achieved.

Introduction to Theater

This course organizes its material around two focuses—the actor and the play. The acting component consists of a variety of opportunities for students to learn technique: voice and speech exercises, character analysis, monologue study, rehearsal, and performance. The play component teaches students how to read analytically and encourages them to understand the play in three distinct but complementary ways: as a reflection of a historical period, as an expression of a writer's world view, and as a blueprint for action. Finally, students learn to evaluate both the play and the performance, and in doing so they bring together the two focuses of the course—actor and play. This course meets five time each week. No prior preparation in theater is assumed. Students are graded on their performances, their written work (character studies, critical reviews, research papers), their participation in the class, and a culminating project.

At the beginning, the course generates and appeals to the students' interest in learning to perform. The teacher stimulates their motivation by giving them the rudiments of actor training. They perform a series of theater games and improvisations, which encourage them to respond actively to each other. They do voice and diction exercises. They also choose and memorize a two-minute monologue, which is then worked on in class, incorporating the class's suggestions for improvements.

The term project is a production book for the simulated production of a one-act play. It contains a plot summary; an analysis of the theme and the characters; scene, costume, makeup, and lighting designs; and a cued script for the stage manager.

Another aspect of the course is that it encourages students to sharpen their observational skills with respect to theater and to learn to express their opinions about actual performances. This part of the course comes to sharpest focus when students attend a performance by a professional company. Afterward, they write their

own critiques of it, separating their opinions from their direct observations. They read one another's critiques and, whenever possible, compare them with the written reviews of professional critics.

Acting and Directing

The effective interaction between the director and the actor is crucial to the success of a theatrical production. This course focuses on these two roles and the way they intertwine with each other.

At the beginning of the course students learn the rudiments of acting through some basic exercises and improvisations. These elementary exercises progress to the point at which students act out simple scenes. They learn how to analyze a play from the actor's point of view.

Once this part of the course is under way, a second strand is taken up—the role of the director. Students learn the tasks of the director and how they fit in with the function of other people on the creative team—the technical director; the scene, lighting, and costume designers; and the house manager. In this context, the students take up basic exercises in directing technique. They study plays from different periods as blueprints for theatrical interpretation and action.

Perhaps most challenging and rewarding is an assignment that asks each student to develop a detailed director's script of a full-length play. It consists of a plot summary, character sketches of principal parts, and ideas to consider in casting these roles. It contains notes about the implications of the student's particular approach to the playscript for the set, lighting, and costume design. And it contains enough of the blocking to indicate how the concept that the student would want the final production to manifest can be translated into visual and kinetic terms.

The format of the course is that of a workshop in which each student alternately acts and directs and also helps other students in their projects. They learn how to make analyses and evaluations of one another's work as well as of the plays or scenes they are studying and interpreting as either a director or actor. Students are evaluated on the basis of their written work, projects, and in-class performances.

Music

The general outcomes of high school arts education may be specified, according to the Green Book, as the following skills and kinds of knowledge when the arts preparation of college entrants is in music.

■ The ability to identify and describe—using the appropriate vocabulary—various musical forms from different historical periods.
■ The ability to listen perceptively to music, distinguishing such elements as pitch, rhythm, timbre, and dynamics.
■ The ability to read music.
■ The ability to evaluate a musical work or performance.
■ To know how to express themselves by playing an instrument, singing in a group or individually, or composing music.

Music, as another one of the performing arts, poses a particular challenge to teachers attempting to design balanced curricula. Many have developed excellent strategies for teaching performing skills—whether in choir, band, or orchestra. Yet, these same teachers may find it difficult to accomplish outcomes related to a knowledge of music history, style, theory, and criticism. The challenge is to achieve polished levels of performance—often in a very limited time period—and also to help students examine carefully and caringly the structure and historical background of the works they are performing.

For the purposes of college preparation, a balanced approach to music curriculum is essential: students need to be prepared as listeners as well as performers. Preparation in listening skills involves understanding the cultural context of the music they hear, knowing some music history, and studying musical form. Most likely, they will discover that their performances are enhanced by this larger awareness. In addition, a well-designed high school music curriculum provides many connecting links to other academic subjects and helps students develop the Basic Academic Competencies.

Two solutions are possible. On the one hand, schools may offer students two separate courses, one of them emphasizing perfor-

mance techniques and the other concentrating on historical and analytic aspects of music study. These opportunities are most effective when neither course dwells exclusively on its main emphasis. On the other hand, schools may choose to balance these emphases within the framework of individual courses.

In this section, two high school music courses of the second sort will be described. Although they are very different, they have the same goals: for students to learn to listen to, identify, describe, evaluate, read, and perform music.

Chorus

This year-long course has six separate aims. First, it teaches basic music skills, particularly those related to reading and notation. Second, it teaches students specific elements of vocal technique and performance. Third, it introduces students to concepts of musical form, style, and harmony. Fourth, it exposes students to music from eight stylistic periods in Western music as well as works from non-Western traditions. Fifth, it allows students to study, master, and perform one major work. And sixth, it helps students to begin developing skills in critical listening. After this course students may enroll in a second-level course in choral music, and this second-level course may be repeated. It is possible for the course described below to be modified—changing both the exercises and the repertory—so that it could profitably be taken more than once.

Classes meet five times each week for the school's standard 50-minute period. While the course is open to all students, the teacher tries to achieve a balance of voice types in establishing the enrollment. Students receive a grade based on written assignments and evaluations of their progress in performing and listening as well as in general musical knowledge.

At the beginning of the course, students learn the symbols used in music notation (clefs, pitch names, rhythmic notation, dynamic and tempo markings, meter, and key signatures). After this introduction to notation (which for some students may be a review), they begin simple music-reading exercises, clapping out rhythms and singing melodies. Styles as diverse as plainsong, folk melodies, and popular tunes are used. Throughout the year students continue to

improve their sight-reading skills, moving from unison singing to two- and three-part singing.

As soon as sight-singing is under way, students begin to learn about the human voice as a musical instrument. They develop good singing habits, including proper breathing and posture, tone production and resonance, and the formation of vowel and consonant sounds. They learn the special vocabulary used in connection with singing (such as "vibrato" and "register"). They learn how to compare the tone color of different voices (their own, other class members', and professional singers'), becoming sensitive to the way in which vocal quality can communicate the intent and style of the music. They listen to recordings and discover how the voice has been used by composers through history. They experiment with their own vocal expressive capacities. They expand the range of their possibilities by improvising in various styles. For example, doing African chants or jazz improvisations or working with simple scalar motifs can stimulate the students' desire to express themselves vocally, both as individuals and as a group.

They sing and analyze 16 works (some of them fairly short) to learn how vocal and choral technique developed from medieval plainchant through seventeenth-century bel canto styles to twentieth-century popular styles. As they learn to sing each of them, they also learn about the historical context of the work, its form, and the composer's expressive intent. The latter is often illumined by comparing two settings of the same text composed in different centuries. (For example, the sixteenth-century setting of "O Mistress Mine" can be compared to Vaughan Williams's setting.)

During the spring term students study and prepare for public performance a large work by a major composer. Examples are Vivaldi's *Gloria*, Haydn's "Lord Nelson" Mass, Schubert's Mass in G, and Fauré's Requiem. Students not only learn to perform the work; they also study its form, style, and use of instruments and something about the composer and the historical context of the work.

Throughout the year students hone their abilities as critics: they are repeatedly asked to listen perceptively to their own and others' performances. Singing in small groups such as quartets and octets is encouraged as training in listening. Through critical listening

students learn about good intonation, intelligible diction, and the effective communication of musical intent.

Introduction to Music

The intent of this full-year course is to develop listening skills; introduce students to the structure, materials, and literature of music; and lead students to understand that both composition and performance involve solving problems as well as expressing oneself. This course is designed for students with no preparation, but it could be modified to become a one-year course for students who already have some fundamental skills in sight-singing or playing an instrument. It could also be expanded into a two-year course.

This class meets five times a week. Students are expected to do homework of various kinds, including short reports (one per month) that require some library research and out-of-class listening assignments made available on tape cassettes. In different years the music teacher has worked with social studies, English, science, and art teachers in developing joint assignments. For example, one year a short unit on acoustics was developed in conjunction with the science teacher; a study of a choral work has involved analysis of the text in an English class; the study of the historical context of a particular composition has often been coordinated with work in a social studies class.

At the very beginning of the course and continuing through the year, students work simultaneously on improving their listening skills and on mastering the rudiments of musical notation and the basic musical terms and concepts. For example, they study the concept of harmonic and melodic relations; they learn the use of chord progressions and how to notate them; and they learn to hear consonance and dissonance and dominant–tonic relations in phrases of post-Renaissance music. Students also listen to whole compositions. Their understanding of these works is enhanced by an introductory-level study of the works' place in music history, of the development of their forms, and of the way that the elements of music have shaped the style. Students use scores or graphic illustrations of the music to study thematic recurrences, the tonal scheme, and the use of different instruments. They are asked questions such as, what is the effect of playing this passage on the

viola rather than on a flute? And, how does the melodic material change as it reappears throughout the work?

Later in the course, they compare and contrast two twentieth-century works: the Lennon and McCartney song, "Yesterday," heard on a recording made by the Beatles, and Stravinsky's *Firebird*. They study rhythmic and harmonic structure in both, as well as the use of instruments and voices. They also study the backgrounds of the composers and analyze the works as a series of musical challenges and expressive problems to be solved. They probe the relation between musical style and sociological context.

This class is enhanced by instrumental and singing opportunities for the students. These are organized around the works being studied or other works by the same composers that are more appropriate to the students' limited but growing abilities and to the instrumental combinations, if there are any available. Opportunities for the class to sing the melodic content of the works are crucial in the course.

Dance

When the prospective college students' preparation is in dance, it involves the following knowledge and skills.

- The ability to identify and describe—using the appropriate vocabulary—dances of various cultures and historical periods.
- The ability to analyze various techniques, styles, and choreographic forms.
- The ability to evaluate a dance performance.
- To know how to express themselves through dancing or choreography.

Teachers of dance have special challenges in designing their courses, challenges not encountered in any of the other art forms. Chief among these is the fact that dance requires a high degree of physical strength, coordination, and body knowledge. Without proper training and drill, students can do physical damage to their bodies. Safety is an important issue, and any student who wishes to participate in dance must make a commitment to regular exercise and physical drill. The design of class periods must also respond to this need. Three 90-to-120-minute sessions a week, under a

teacher's close supervision, are preferable to shorter or less frequent classes or more sporadic scheduling. The appropriate space is large and well ventilated; it has mirrors, a barre, equipment for playing accompanying music, and a resilient floor. Concrete floors or tile installed directly over concrete must be avoided to prevent injury.

A second challenge for the teacher of dance is that the art form is in many ways ephemeral and difficult to study except in actual dancing. Visual art, in contrast, offers permanent records of artworks to study, either in their original form or on film. A dance "score" is so difficult to read that many dance instructors do not teach dance notation and score reading. Dance films and videotapes are of limited value in studying the art form, because they lose the important relational aspects that depend on three-dimensionality. Live performances, then, are really the only reliable vehicle for studying dance outside the studio, but many dance teachers and their students do not have the time or resources to attend performances outside school.

Finally, the dance teacher is tempted to concentrate exclusively on physical preparation, as dance demands so much of the body. In many schools, dance is part of the physical education program. This arrangement increases the risk that a student will not receive balanced instruction covering the theoretical, analytic, and historical aspects of dance. The two courses described below attempt to meet the challenges described above and to meet the need for balanced curricula described in Chapter 2.

Dance Technique and Choreography

This course introduces students to dance technique, improvisation, and choreography; it helps them develop their powers of observation and analysis; it offers some exposure to the history of movement and of dance as an art form; it helps them understand movement as communication; and it gives students an opportunity to experience the rigors of rehearsal and the performance of dance.

Students begin learning about the nature of movement by learning about time, weight, space, and energy. They do some general body exercises (stretching, twisting, turning, bending, swinging, bouncing, sliding) and also learn some standard dance exercises

(such as pliés, relevés, and tendus). They learn the historical precedents for these exercises (fencing and court dancing) as well as their relationship to the martial arts. When a particular dance style is demonstrated or learned (ballet, flamenco, jazz, modern), reference is made through lecture, videotape, or film to the historical period from which the style emanates.

Although the course initially emphasizes the mastery of technical skills, students are also asked to recognize movement sequences and to improvise movement spontaneously. Such recognition and improvisation are their first steps toward an understanding of the choreographic process. Students discover that, in addition to the standard movements that are taught in technique class, their own bodies can suggest other movements that are well suited to them. In order to discover these movements, students are told to move forward, backward, and sideways; to make up different foot patterns; to use large spaces and confined spaces; to move at different speeds; and so on. Or they might take a movement sequence in one style, such as ballet, and perform it in a jazz style. They are then given an opportunity to present a one-minute excerpt from their improvisation to the class. Fellow students are told to take notes, develop their own ways to remember and notate the movements, and write critiques. Later they are formally introduced to notation and dance criticism as practiced by professionals. As the course continues, they continue to develop their notational and critical abilities, based on these models. They also look at films, videotapes, and television broadcasts of dance performances to sharpen their ability to observe, remember, notate, and evaluate.

A major portion of the course deals with choreography, rehearsal, and performance. Initially, students are encouraged to work alone, experimenting with the difficulties of simultaneously creating, remembering, and evaluating movement. Later, the tasks of choosing among different possibilities, making transitions, and getting "unstuck" in the creative process are facilitated by class critiques of works in progress. Special classes are devoted to discussions of the choice of music, the number of dancers, costume design, use of stage light, as well as the dance itself. A major component of this course is a final dance concert, produced by the students, which features their own performance and choreography. In addition to student work, a guest dancer or dance company may be invited to

appear at the same concert to enhance the excitement of the performance. Considerable time is devoted to learning rehearsal skills, concentrating on the efficient use of time and the ability to follow direction and accept criticism.

Introduction to Dance

The purpose of this course is to introduce students to a range of dance styles and traditions and to teach them about the various elements that contribute to successful dance performances. The culture and history of dance are studied by encouraging movement studies based on a specific historical period or place, such as the classical dances of India. The opportunity to see professionals at work, either in performances or in rehearsal, greatly benefits students in this course. The course is one semester long but can be adapted as a full-year course. It requires regular writing assignments and examinations.

On the first day of this course, students are introduced to a basic warm-up routine consisting of bending, stretching, swinging, breathing, and relaxation exercises. In order to improve muscle tone and body flexibility, they are encouraged to do these exercises both in and out of class. They are also encouraged to keep a diary describing the movements that they experience in class; they are told to describe the feelings and expressivity that these movements convey. After the warm-up routine in class, students play various games (such as responding to a sound in movement, carrying on a movement "conversation" in a group, expressing a feeling or a personality through a series of movements). These activities later develop into formal dance instruction in which examples of dance forms and styles are studied.

At the same time that students are exploring movement, they are also studying dance as an art form that can reveal the customs, beliefs, and culture of a country or a period in history. Often they begin with Russian classical ballet; they view videotapes, and they study Russian history. They learn about imperial support for ballet in the time of the tsars and the place of ballet in the social activities of the upper classes. They also study the art form itself, analyzing the use of the body in expressing movement, the emphasis on story line, and the tradition of Russian ballet music.

Students move outward from Russian classical ballet by making comparisons with the dance traditions of other countries and periods (such as Spanish dance, Afro-Cuban dance, and social dance in the United States). Students are encouraged to consider social and political questions as they view different forms and styles. (For example, what does dance in this culture suggest about the relative place of men and women?) Students also analyze aspects of the dance form itself. They are asked, for example, to describe the extremely stylized elements of Indian dance and to compare them with the expressive elements of modern dance in America as exemplified by Martha Graham. Whenever possible, students practice the same dance movements that they are analyzing. In some cases (as in certain folk and ethnic dances) they can prepare complete dances.

The final component of this course is an analysis of some of the production elements, in addition to choreography and dancing, that contribute to a successful performance. Students learn about music, stage lighting, performance space, scenery, and costumes. When they study costumes, for example, they learn about fabrics, discovering which are lightest, which have bulk and weight, and which stretch. They look at those costumes that are meant to hide the dancer's body or personality and those intended to reveal it. They learn about the texture, color, and pattern of the costumes and think about how each of these elements can contribute to the mood and feeling of the production. In a year-long course, they may also construct costumes, especially if another class is planning a performance. In all cases, these analyses of production elements are applied to live or filmed dance performances, as students are asked to use what they have learned in analyzing what they see.

Other Directions: Additional Patterns for Teaching the Arts in High School

Lasting understanding and deep excitement about the arts takes learning, not just exposure. Consequently, many experienced arts teachers argue against courses that expose students to a smorgasbord of art forms or that combine the arts with other academic

subjects. But, just as artists have often enriched their works with knowledge borrowed from science, mathematics, and other art forms, some arts teachers have designed courses that differ from the familiar format of courses that are concerned with only one of the arts. While these other courses are no substitute for concentrated experience in a particular art form, they raise interesting possibilities for the kinds of courses that might be offered in addition to fundamental training in the visual arts, theater, music, or dance. In particular, such courses may provide significant ways of linking the arts to other basic subjects. Two such courses are described here as a way of stimulating thought and discussion.

Crossing Artistic Disciplines: A Course on Arts and Cultures

This course, "Arts and Cultures," was originally designed by an English teacher and a dance teacher as a way of opening a dialogue about cultural diversity in an urban high school. The first portion of the semester-long course was used to make a close study of other cultures' contributions to current American art forms. Students began by studying the contributions of Afro-Caribbean forms of dance and music to the work of choreographers such as Alvin Ailey, as well as to popular dances. Subsequently, students listened to live and recorded readings of the short stories of Zora Neale Hurston, James Baldwin, and Alice Walker. Throughout the course, the instructors taught the students a number of techniques to help them observe and describe the distinctive qualities of a particular culture's approach to movement or narrative. For example, students compared segments of Caribbean group dances and corps de ballets scenes from European ballet; they contrasted thematically similar stories by black and white writers.

In the second portion of the course, students worked closely with either the English teacher or dance teacher in a laboratory setting. Students were given the problem of selecting an idea, tradition, or ritual from their own cultural backgrounds that could be used as the basis for a short dance composition or piece of writing. During this portion of the course students kept journals of their ideas and worked in small groups. In weekly conferences at which students

shared their work, the teachers helped students express their own ideas and act as thoughtful critics for one another's work.

As the course continues to be taught, teachers are developing new materials and formats. Currently, the course is taught collaboratively by full-time teachers working with visiting artists. In one recent semester, a Hispanic sculptor introduced students to the monuments of Aztec and Inca cultures and discussed the influence of their size, geometry, and mystery on his own work. In the lab portion of the course he worked with students on a series of monuments incorporating images, forms, and materials from their own cultural backgrounds.

Crossing Academic Disciplines: Music and Computer Science

Again and again over the years, technology has improved musical instruments and sometimes even developed wholly new instruments, from saxophones to synthesizers. More recently, the advent of computer technology has presented a new opportunity for combining technology and music studies. The following semester-long course involves intermediate-level computer-programming students in a threefold approach to understanding and becoming involved in computer-based composition.

The course is evenly divided between class sessions that concentrate on analytic and historical understanding of music and sessions during which the students work on their own compositions. In the class sessions, which are led by the music teacher, students investigate the history of the relationship between technology and music. They begin with the nineteenth-century modernization of orchestral instruments, and later they study the twentieth-century interest in new forms of sound production evident in works by composers such as John Cage. Later, they study the invention and uses of a variety of electronic instruments and computer-generated music.

Throughout these sessions students analyze particular works, listening closely to recorded performances and studying whatever scores there may be. Much of the class discussion focuses on the way in which new forms of sound production spark new conceptions

of musical sound and form. When possible, students listen to broadcasts of new music over public radio. They are encouraged to evaluate what they hear and talk about the issues of making sense of music that is unfamiliar.

Parallel to the history and listening components of the course, students participate in composition sessions in which each of them develops a short piece on a microcomputer. In these sessions, students learn how to apply their basic knowledge of programming to produce various types of sounds, rhythmic patterns, pitches, and timbres. Students begin their compositional explorations using existing software, which permits them readily to create simple musical patterns such as scales, repetitions, and inversions. In a section of the course, taught jointly by music and computer-science instructors, students graduate to writing their own programs, which allows them to invent a wider range of sounds and patterns. At regular intervals students play their works in progress for one another. These sharing sessions provide a source for new ideas as well as practice in listening, discussing, and evaluating one another's compositions. During these composition sessions, the teachers encourage students to push beyond imitating or using gimmicks toward genuinely imaginative and artistic uses of the novel medium.

IV. Teaching the Arts

Outstanding arts courses are not developed only out of texts, slides, or studio spaces—they are constantly invented, tried out, and refined by skilled teachers. Lesson plans, field trips, and rehearsals are wooden until teachers translate skills and concepts into vital classroom experiences. The purpose of this chapter is to look in on some of those teachers and their classes. By observing actual teachers working in classroom settings, we can see how the aesthetic skills described in Chapter 2 and the courses discussed in Chapter 3 can be realized in thought-provoking and powerful ways.

In the first vignette a dance teacher works with a student by helping him to engage in *creating his own work*. In the second one a theater teacher explains how he helps his students to *understand and appreciate different artistic styles from representative historical periods*. The third demonstrates how a music teacher encourages students to *examine a performance and a composition at a number of levels and from a range of vantage points*. The fourth vignette offers a glimpse of a visual arts teacher using close observation in order to teach students to *appreciate how people of various cultures have used the arts to express themselves*.

The final two vignettes are included to illustrate the teaching of artistic skills and understanding outside the fine arts curriculum. In one, a visual arts teacher is shown helping students acquire the ability to *carry a work through several stages of development*. Though her class may have a more applied, vocational slant, it can still be beneficial to students who are bound for college. In the final vignette, we see a teacher using computers to help a student evaluate a short story in progress. It shows how students can be taught to *use new skills, tools, and processes to develop more effective means of artistic expression*.

Like Chapter 3, this chapter is not meant to be prescriptive. We do not suggest that teachers utilize any of the ideas and techniques in this chapter unless those ideas happen to be helpful. These

vignettes are meant to illustrate the role that an imaginative teacher can play in solving typical classroom problems and in designing learning activities that assist students in becoming better prepared for college and lifelong learning in the arts.

"I Can't Do It"

Many students suspect that in order to participate in an arts class, they should be at least talented, if not also inspired. Students often will do exercises or group work, but they hang back when asked to create even small-scale projects of their own. In order to develop students' willingness and ability to create their own work, *teachers have to overcome some natural adolescent reluctance to expose themselves and their work. Here, a teacher alerts a student to the raw materials that his own life provides. At the same time she breaks up the process of creating a work into steps, without dictating either the form or the content of her student's work.*

When Sam arrives in Miss R's dance class, he takes up a place in the back row. Soon Miss R comes in. She asks the class to go through the basic exercise and warm-up routines.

Miss R's voice breaks through the thumping and puffing sounds: "All right, I want each of you to move in a space of your own. Think of a movement you do every day. Repeat it over and over until it becomes a pattern. Stylize the pattern. Turn it into an across-the-floor movement. I want about half a minute's worth of movement from each of you."

Sam leans against the barre and begins to work on movements taken out of the warm-up.

Miss R comes over: "Something from *your* life."

Sam: "Like what?"

Miss R: "Running to catch the bus? Going up the last flight of stairs? What sports do you like?"

Sam: "Track in the spring."

Miss R: "Think of one movement that's very sharp, one your body really remembers. I'll come back."

Sam begins to work on a motion that takes him from a low crouch to a standing position. He experiments with the rising motion, trying different arm movements. He struggles to find a way to carry the

rising motion into a movement that will take him across the floor.

Miss R returns: "Okay, what have you got?"

Sam: "The way you feel when you get into position to start a race. Well, and then the going forward fast."

Miss R: "So you have this beginning, this part." She performs Sam's crouching and rising. "But you have to build on it. What can you add onto the start?"

Sam goes back to the start of his pattern. "It could start lower, maybe tighter, this way." He tries a tight, low crouch.

Miss R: "Okay, that looks tense, like a spring. How are you going to unwind? Is that what you want? Use the mirror."

Sam turns and watches as he tries various starting positions. He lies down flat; he pulls up one knee to his chest; he thrusts his arms down, then back, so they parallel his extended leg. He tries looking forward, stretching his neck out. He tucks his head. He turns his head to one side and thrusts the opposite hand out.

Miss R: "Good, that gives it thrust. Now think about carrying that thrust forward and up. How are you going to get all the way up?"

Again, Sam experiments, watching the results in the big mirrors. He crouches, rises, and takes off across the floor.

Miss R: "Remember, this is dance. You don't have to do everything you actually do when you're on the track. You can pick and choose. It's okay to exaggerate. You want something that's interesting to watch."

Sam goes back to his low-slung starting position. He plays with a sharply rising motion that carries him to his toes, with his arms sweeping up and forward. He falls back into his original crouch, following a wide arc. The next time he swings out and forward, almost as if diving.

Miss R: "Good, keep going. Keep thinking in movements. Where should that one go?"

An Argument Worth Watching

Students often sign up for classes in the arts as respites from their more "academic" courses. They may think of performing a play, dancing, or playing music as a way to escape from studying, reading, and writing. Yet, well-balanced curricula in the arts require

these Basic Academic Competencies and tasks. Here, Mr. L asks students to read and study works from representative historical periods and diverse cultures as a way to broaden their understanding of theater and of performance techniques. In the following vignette, Mr. L deliberately uses contrasts between Sophocles, Shakespeare, and modern soap operas to open students' eyes to the elements of theater. His own enthusiastic participation in discussion creates an atmosphere of investment and involvement.

Mr. L teaches theater to high school students and is opposed to what he calls the "let's-let-it-all-hang-out school of acting in which kids 'emote' on stage." He explains: "Part of my job is to convince students that acting is hard work. Adolescents seem to identify with particular actors whose performances appear smooth and effortless. My job is to teach students how much work is involved in making something look easy on stage. Part of that work involves knowing how to analyze a play. You have to analyze plays from different periods if you are going to understand some of the options and choices you have in theater.

"We read and then perform scenes from two great plays—*Antigone* by Sophocles and Shakespeare's *The Taming of the Shrew.* Both of the scenes deal with conflict. The first is the famous confrontation between Creon and Haemon in *Antigone;* the second is the big argument between Kate and Petruchio in *The Taming of the Shrew.* In both cases we begin by analyzing the action. How does the scene begin, develop, and end? What is the source of the confrontation? What are the values of the characters involved? What is the basis of the relationship (father/son, husband/wife, business associate, friend) and what are the psychological overtones in this relationship?

"Once we work through these basics, we can look at the theatrical elements in the plays. This is when students start to learn about theater. We start with the scene from *Antigone.* The issue in this scene is whether secular law should take precedence over divine law—but putting it that way makes it sound flat. This is a great scene; the characters are heroic, they are dealing with important moral choices that are timeless. The style is oratorical and rhetorical. I ask students: Why? When they discover that the scene was originally played in an outdoor amphitheater with several thou-

sand people they figure out one reason: the style had to be large and bold or the scene wouldn't come across.

"Students sometimes complain that they can't identify with the characters in *Antigone* or the situation. They say, 'nobody argues with his father like this.' So we again try to figure out why the language and the action are the way they are. We talk about the fact that the characters in Greek tragedy are all playing predestined roles and the dramatic action follows clear and unalterable rules. In class, we spend time studying these rules, and we learn about performance techniques that grow out of this style of theater.

"In *The Taming of the Shrew* we study a knock-down, drag-out fight between a man and a woman. Students feel right away that Kate and Petruchio are characters with whom they can identify. They learn that Shakespeare's comedy allowed this—not everybody important in the play had to be a king or a prince, and there were plenty of comic leads who were poor or middle class. Kate and Petruchio also seem to behave like ordinary people. I have yet to meet an adolescent female who can't identify with Kate's plight. I ask the students to contrast their feelings toward Kate with their feelings toward Antigone. I ask them: What is it about the style of each play that makes for two such different heroines and two such different reactions?

"I ask students to look for clues that are embedded in the play itself. Language, of course, provides many. In Shakespeare, they are no longer dealing with a translation, so they can analyze the English to try to figure out how words create characters. I teach students to look at what characters say, what other characters say to them, and what is said about them. Shakespeare's rich, poetic language provides a special dimension for character development not always available in other plays.

"In the final segment of the course, I ask students to watch and analyze television soap operas. 'Why?' you might ask. Partly, it's to show them how much they have learned. They now know how to watch the 'soaps' with an informed and critical eye. Sometimes we all watch an argument scene from a television drama and compare it to the arguments in *Antigone* and *The Taming of the Shrew*. We talk about the relationship between the 'soaps' and modern culture. We compare the heroines of the 'soaps' to Antigone and Kate. We discuss the way filmed studio production affects the

dramatic presentation, just as we discussed the influence of the amphitheater on Greek tragedy. But I also encourage students to use their knowledge to evaluate what they hear and see. They can pick out moments when the characterization is flat or trite, and they often notice when the language and action work well dramatically.

"In the first class of the year, you should hear the groans when they hear they have to read Sophocles and Shakespeare. But it makes them much more informed about theater. And, for those who might want to act and direct, they now have a strong base of theatrical knowledge on which to build."

"What Are Those Kids Doing Here?"

How can a teacher develop a teaching strategy that will encourage students to take the time to examine a performance or work of art at a number of levels or from a range of vantage points? *Repeated and thorough analysis requires time and patience, something that often seems in short supply among high school students. The following vignette shows some extraordinary approaches developed by a teacher of instrumental music. Although his band and orchestra students appeared impatient with his deliberate and thorough teaching methods at the beginning of the year, their attitudes had changed markedly by year's end.*

The scene is a downtown concert hall on a Friday afternoon. The event is a regular subscription concert of the local orchestra. The audience consists primarily of older men and women who like to attend concerts during daytime hours. There are also some other recognizable clusters in the audience—some middle-aged adults who appear to be "regulars" (they sit in the best seats), a few music students from the local university, and about 50 high school students.

At first these high school students look a bit out of place: jeans and casual clothes seem to clash with the plush green velour that covers the seats in the recently renovated concert hall. But appearances can be deceiving. These students are probably as well prepared for the concert as anyone in the audience. All are instrumentalists who can appreciate the challenge facing the performers

on stage. They have rehearsed and performed a movement of one of the works on the program. They have studied the music in great detail, analyzing its form and melodic content, its use of various instruments, and its musical expression. They have also studied the life of the composer, and they know about his place in the history of music.

The person who can claim credit for this superb preparation is their teacher, Mr. B, who is responsible for the instrumental music program at a large urban high school. This field trip marks the culmination of a carefully planned second-semester project in which students in both his band and his orchestra have worked on a particular piece of music. They have studied and performed it on a schedule that was carefully coordinated with the performance plans of the local orchestra. The work was a movement from a Tchaikovsky symphony, which was available to the band students in transcription form (a common situation in band literature) and to the orchestra students in a simplified orchestration. Choosing a work that each group could play is an important part of Mr. B's teaching philosophy: he believes it is essential that all musicians learn that they cannot really know a piece of music until they have examined it from many points of view and through a variety of activities.

During the three months leading up to the field trip these students have not only studied the Tchaikovsky symphony and written papers about it, they have practically "lived" it. They have sung all its themes; they have compared three different recordings of it. Many of the students now hear the music in their sleep; they hum it unconsciously when they do homework; they sing the melodies aloud when they feel exuberant. Looking at the students as they enter the concert hall, one immediately senses the excitement of their anticipation, for their teacher has prepared them for this performance carefully, discussing with them specifically what they will listen for and watch for. He knows that this will help them listen with heightened awareness, and he knows further that it will add to their ability to speak in an informed way about what they have heard when they return to class.

During the performance, the students are absorbed. Not at all relaxed, they have been given a complex assignment, which is the final unit of their class project, and this assignment requires intense

observation. First, each student focuses on a particular performer on stage who plays the instrument and musical line that the student has already studied. The students take special note of their musicians' performance techniques: How do they prepare for their entrances (for example, breathing or bow preparation)? What kind of eye contact do they seem to maintain with the conductor? What kind of "ear contact" do they seem to maintain with other players? The students also attend to the conductor's interpretation of the music, noting instrumental balance, tempi, phrasing, dynamics, dramatic pauses, and so on. Finally, the students are asked to form an overall impression of the performance, deciding how well it works as a whole.

The next time these students will be together is on the following Tuesday afternoon. At that time, they will have completed their written assignment: a critical appraisal of the performance of the Tchaikovsky symphony. This is the final unit of a semester-long project, which began with research and rehearsal and ended with two performances—their own and the local orchestra's. Their project book, filled with reports, critiques, and musical analyses, is turned in at this time.

Most of these students will never study a piece of music as closely again. But what they have learned about in-depth analysis will stay with them for many years. They know the Tchaikovsky movement so well because they have done research and analysis, they have performed the piece, and they have listened to others perform it. Their project book is a special tribute to the depth and thoroughness of their work. Many of these students will save it long after other, less important mementos of their high school years have been thrown away.

Shirts and More Shirts

Many students come to high school familiar only with the culture of their own immediate lives. Arts classes offer an important chance to break out of that cultural isolation. In her course, "Introduction to the Visual Arts: Varied Media," Ms. V devotes an entire period a week to helping students become powerful observers and interpreters of other cultures. Ms. V feels that "being able to notice" is

the most fundamental skill in appreciating how people of various cultures use the arts to express themselves. *During these periods she brings actual objects or slides of clothing, pottery, buildings, and tools to class. She and students practice "reading" the objects together—noticing, drawing inferences, asking questions—all based on what they can observe. Throughout the discussion, Ms. V encourages students to share ideas and, at the same time, to think critically.*

The classroom is dark. Ms. V and her students sit in a group in front of two brilliant slides. One shows a polyester shirt printed with a sharp black and yellow checkerboard pattern. The other slide pictures an Apache medicine man's shirt made from painted buckskin. The group studies the slides for several minutes.

Ms. V: "The slides show you two shirts. One was made in Hong Kong for export to the United States in the 1960s, the other is an Apache shirt made sometime between 1860 and 1880. Each one is a sample of a particular culture. By looking *just at the shirts*, what can you tell me about these cultures?"

Lola: "One is machine made and one is handmade."

Ms. V: "What do you *see* that makes you say that?"

Lola: "The bright, patterned one is so even and exact, only a machine could have done it. The other one has places where the lines aren't even and the shapes change a little bit, so I think it was made by hand." (With this, Lola walks over to the slide and traces with her finger a line of triangles on the buckskin shirt, pointing to triangles that are smaller or tipped.)

Peter: "The buckskin shirt was made in a culture that loves nature, and the polyester shirt was made in a culture that doesn't care about nature."

Ms. V: "That's a big statement. What do you *see* in the shirts that lets you say that?"

Peter: "The polyester shirt hasn't got anything natural in it. The buckskin shirt is all natural: skin, hand-painted, looks to me like vegetable dyes."

Nava: "Yes, but you could have a culture that loved nature but used plastics and chemicals to express it."

Peter: "No, that's not what I mean."

Ms. V: "Look again at the shirts. What else do you see that's evidence for your idea?"

Nava: "The images on the shirts. The modern one has got just black and yellow squares, nothing like plants or water. But the buckskin shirt has all those lines of raindrops and stars." (She points to strips of pointed and drop-like shapes in the border.)

Peter: "But maybe those are just decorations. How do we know that those are raindrops? Maybe they are just patterns like the checkerboard in the other shirt."

Ms. V: "What else in the shirt might help you answer the question?"

Peter: "Up on the shoulders there is a sun on the left and a crescent on the right. So maybe, then, it would make sense that those other shapes have something to do with weather."

Ms. V: "So the images in the Apache shirt might well have to do with weather. What about your earlier idea that it is a shirt that comes from a culture that loves nature?"

Ricardo: "Maybe you could say it comes from a culture that thinks about weather a lot."

Ms. V: "Say more about what you mean."

Ricardo: "I was thinking—it is handmade, it comes from a culture without many tools. It isn't sewn. No buttons or anything. So it is a culture where people probably don't have much protection from nature. So the weather is probably very important. But maybe they don't love it."

After this discussion, Ms. V shows students slides of Apache dwellings and artifacts, and they read a few short translations of Apache chants. Together they try to integrate their observations into a broader understanding of Apache culture, coming back to Peter's original question about the Apache view of nature. Using this question, Ms. V asks students to think about how a viewer goes from cultural artifacts to understanding a culture. Throughout the rest of the semester, the group returns to the issue frequently.

Blue Potato Chips

Just as students may think they "know" a work of art after they have examined it once or twice, they often believe the hard work in

making a work of art is finished once their first drafts, sketches, or studies are completed. Yet, the ability to carry a work through several stages of development *is an essential part of the artistic process. Students must learn that they cannot rely solely on "inspiration" and that they must master the essential skills of refining and polishing. Students can learn these skills through a wide range of arts experiences. The teacher in the next vignette uses the concrete demands of a commercial art assignment to teach students that there are many steps involved in completing a successful artwork.*

A group of students is sitting around a large work space. "Do you really believe that anyone would eat a blue potato chip?" one of them asks.

This seems an odd question in an art course for high school juniors and seniors. The course is called "Commercial Design," and at this moment one student, Delores, has asked a question about a package designed by one of her classmates, Ned. The discussion has become heated. Several students have argued that Ned's package is an extremely successful rendering of the assignment, which was to design a container for a new brand of potato chips. Delores's question has taken the wind out of their sails for the moment. Despite the excellent attributes of Ned's package, they have to admit that the blue cellophane paper makes the potato chips look distinctly unappetizing.

This assignment has always been a particular favorite in the course, and part of the reason for it is the cleverness with which Mrs. A, the teacher, has prepared the students for it. While the full assignment is not given until April, preparations for it began in September. On the second day of class, Mrs. A writes the following statement on a large piece of newsprint and tapes it to the wall:

> You have a client who is bringing out a new line of potato chips. He has turned to you to design a container for the product. Please take some time now in class to write answers to the following questions. (By the way, this is not a test and you will not be graded.)
>
> 1. What are the major practical considerations that will limit your choices in designing the container?
>
> 2. What are some of the psychological and artistic considerations that might influence your choices in designing the container?

3. What specific elements of the product and the package will you want to discuss with your client in the first meeting before beginning on the design?

4. Discuss the steps you will go through in designing the container.

After half an hour, Mrs. A collects the papers and carefully puts them away. During the remainder of the class and throughout the next class, the students discuss their responses to the questions. Mrs. A makes no definitive statements, but she does ask some leading questions now and again: "Are you worried about spoilage or breakage? Do you care whether the people coming to buy potato chips in the supermarket can actually see the chips in the package? What do you suppose your competition's packaging looks like?" The students appear to enjoy themselves in the discussion. There is much joking and attempted cleverness in the responses to Mrs. A's questions. She does not appear concerned and, when the class is finished, says nothing more about potato chip packages.

In fact, nothing more is said about potato chip packaging until the following April, after considerable study of the elements of commercial design. Mrs. A has taken the students through a history of commercial design. She has introduced them to the grid and its utilization in commercial art, the concepts of positive and negative space, balance and symmetry, rhythm and kinetics, color theory, and typography. She has taught students how to prepare a mechanical.

They have also learned about the commercial design environment, about corporate identity programs involving integrated design for everything from stationery to storefront and truck signage. The students have learned the role the designer plays in the marketing process. Indeed, by the time Mrs. A returns to a discussion of potato chip packages, she is dealing with a class of students who have a far greater degree of sophistication about commercial design.

Mrs. A likes students to know how far they have progressed. She also has a sense of humor. During the first week of April, she carefully unfolds a familiar piece of newsprint and tapes it to the wall. "You have a client who is bringing out a new line of potato chips . . . ," it begins.

"Hey," says one of the students, "we've already done that assignment."

"Then you should have no problem doing it again," Mrs. A answers with a smile.

The students begin to work on the familiar assignment. At the end of the class, Mrs. A collects the papers, carefully matching each student's April effort with the paper from the September class. Students volunteer to read what they have written—but they must read both papers. The differences are staggering to the students, who spend three classes discussing the specific design problem and reviewing what they have learned over the course of the year. At the end of the third class, Mrs. A tells the students they are now actually to begin work on the task of designing a potato chip package. She outlines the client's needs and wishes and tells the students that they have the next three weeks to work on the assignment.

At the end of three weeks, students present their work to the class. When students are not presenting their own work, they are to play the role of the client, commenting on the strengths and weaknesses of the concept and the design and requesting changes. Ned learned, through the class critique, that blue cellophane will simply not do. Like all the other students in the class, he will have one more week to work on his package before the final presentation of his work.

The Hedgehog and the Computer

Effective instruction can also occur when arts teachers join forces with other teachers. Ms. W, a writing teacher, joined forces with the computer department to invent innovative ways to teach the age-old skills and techniques required in a particular art form. By working with computer instructors, she learned how to use the capacities of word processing to help students develop a variety of skills, tools, and processes in order to express themselves effectively. She also discovered ways to use the computer to teach methods of comparing drafts, revising, and developing an effective writing style.

Ms. W walks over to one of the computers where a student, Lisa, is peering at a computer screen with a single paragraph in the top half of the screen:

Alyssa's brother, Arthur, was back from camp. For most of the summer he had been 250 miles away. Now he was at the dinner table, talking fast and loud about his trip to Tunk Lake. Alyssa stared at him. His skin was tan, almost black-brown. His eyelashes were bleached, and somehow the eyes inside them looked oval and gold, not brown and round as she remembered. Before he left he had gotten "a buzz," but now his hair had grown out into a stiff, brown mane. A neighbor had reached out and run her hand through it.

"Ah, in Turkey we call this animal 'kirpi.' Here you call it what?"

"Hedgehog," Alyssa said.

Lisa leans back from the screen. "I like the end, but not the start."

Ms. W: "What do you like about the end?"

Lisa: "The way it's clear how the sister sees her brother—like a strange, little animal."

Ms. W: "You want more of that at the beginning?"

Lisa: "Maybe. . . ."

Ms. W: "Okay, look at the sentences you like. How did you make the sister's feelings come out?"

Lisa studies the screen: "By writing about how she saw him—stuff like the 'oval eyes,' the 'brown mane,' the 'hedgehog.' Is that what you mean?"

Ms. W: "Right. So how can you bring that out earlier?"

Lisa: "Cut the stuff about Tunk Lake?"

Ms. W: "That's going to leave a reader without much to go on."

Lisa: "Maybe start the animal idea earlier."

Ms. W: "Okay, but don't do it with a sledge hammer."

Lisa copies the original paragraph into the lower half of the screen and works on the first few sentences. She changes the third sentence a number of times, writing:

Now he sat at the dinner table, curled over his plate. . . .
Now he sat at the dinner table, hunched over his plate. . . .
He had just settled at the dinner table. Hunched over his plate, . . .

Ms. W comes back: "Yes, that's the idea. You want to be careful, though. You don't want to go wild with the animal stuff. Keep in mind the tension you want—a creature, but a small and attractive one. That will help you make the decision about 'hunched' or 'curled.' You might also want to try another kind of change. See what you can do to keep Alyssa's point of view clear without having to come out and announce 'Alyssa stared at him.' "

Lisa: "But how?"

Ms. W: "Experiment. Go have a look at what Jaime is doing. He's working on his opening too."

Lisa and Ms. W cross the room and read another student's work. Jaime's story begins right away with pronouns and definite articles. Ms. W talks about how that kind of detail in language can create a sense of intimacy and imply a point of view. Lisa returns to her own computer. She saves the second version of her opening on the disk and then begins work on a third version.

For most of the summer her brother had been 250 miles away in camp. Now he was back at the dinner table, curled over his plate, talking fast and loud about his trip to Tunk Lake. She had never noticed the hairs on his arm before. Inside his tan face, his eyes looked oval and almost gold, not brown and round as she remembered them. The day before camp he had gotten a "buzz," but now his hair looked thick and mowed. Just yesterday a neighbor had run her hands through it.

"Ah, in Turkey we call this animal 'kirpi.' Here you call it what?"

"Hedgehog," Alyssa said.

V. The Arts and the Basic Academic Competencies

As we have seen, the arts offer important subject matter to students preparing for college. The courses discussed in Chapter 3 and the specific teaching and learning situations described in Chapter 4 suggest the rigor and depth possible within each of the specific arts disciplines.

However, as was pointed out in Chapter 2, there is also a relationship between a mastery of the arts and the development of the broad academic competencies that students will need in all college subjects—reading, writing, speaking and listening, mathematics, reasoning, studying, using computers, and observing. It is important to study the arts for their own sake; it is also important to recognize that they provide additional opportunities to enhance these basic skills. A teacher can strengthen the connections between the specific arts disciplines and the academic competencies and can explain these connections to the larger school community.

In this chapter, the connections between each of the Basic Academic Competencies and the arts are treated. The competencies are outlined, using whenever possible the descriptions in *Academic Preparation for College*. Specific examples of learning experiences in the arts are also described in order to point out the connection between the arts and the development of the competencies.

The Basic Academic Competencies

Reading

Reading is a competency with many levels, ranging from simple decoding to complex interpretation. Particularly at the more sophisticated levels, the arts can make strong contributions to students' reading abilities.

Moreover, through the arts students may become involved in developing decoding and interpreting skills—"reading" skills, so to speak—in symbol systems other than conventional linguistic ones. They may read musical scores, dance notations, diagrams that sketch the structure of a painting, or tables containing firing temperature for kilns. This experience with a wide range of codes or forms of information enhances basic thinking skills as well as reading itself.

At the most literal level, reading involves taking meaning from written texts. Many activities germane to the arts, from mixing glazes to memorizing play lines, provide students with motivating situations in which to practice the skills of decoding and understanding written materials.

An essential part of reading is identifying and comprehending the main and subordinate ideas in a written work and summarizing those ideas in one's own words. This skill often develops naturally as one studies the arts. For example, theater students learn that a play may have a main theme or plot with several supporting ideas. (For example, Shakespeare's *Romeo and Juliet* deals not only with young and innocent love but also with deep family hatred.) Similarly, music students are engaged in a task supportive of reading competency as they learn that reading (and later performing) a musical work requires the ability to differentiate between the chief melodic line, subordinate lines, and accompaniment.

Reading involves the ability to vary one's reading speed and method (survey, skim, review, question, and master) according to the type of material and one's purpose for reading. Theater students in particular can develop this skill. They must learn the important difference between skimming a text quickly for themes and overview of character, reading slowly and orally for expressive content, reading the same material repeatedly for memorization and mastery of lines, and reading silently (but slowly and carefully) for deeper meaning.

Reading also involves the ability to recognize different purposes and methods of writing, to identify a writer's point of view and tone, and to interpret a writer's meaning inferentially as well as literally. In the arts, students learn to read with different expectations when a text is to be read literally (for example, a book on the science of color or sound), when it is to be read for its expressive

content (for example, a poem that is being set to music or dance), or when it is to be read for analysis or interpretation (for example, a book of art criticism).

The ability to separate one's personal opinions and assumptions from a writer's is involved in reading. In reading a review of a play, a concert, or an exhibition, students learn to separate their own opinions about the merit of a work of art from those of the critic. They also have a good opportunity to differentiate taste from direct observation and to examine a variety of written interpretations of a single work.

Where students have the opportunity to read what others write about the arts, they can engage in what might be termed "integrative reading." Suppose a student reads Van Gogh's letters and the contemporary reviews, which shunned his paintings as twisted and bizarre, as well as the praise of critics some 50 or 100 years later. That student would face the challenge of integrating diverse, and even conflicting, information. Such an exercise furthers the student's ability to integrate sources in other reading experiences.

Another complex reading skill is that of "close" or "many-layered" reading, which requires that a reader draw inferences not just from words but from sound patterns, sentence structures, word choices, images, and figures of speech. Close reading of plays is a clear example. The study of a music score, either in practicing for a performance or in making an analysis, or intense concentration on the details of a dance or painting also helps train students to notice *all* the details in their reading. The ability to recognize subtle messages, to see beyond what is written to what is implied—to draw inferences, to catch irony, sarcasm, or double meanings— also plays a significant role in interpreting journalism, political speeches, and advertising. It is crucial in the arts.

Writing

The kinds of writing associated with study in the arts can afford students numerous opportunities to develop competency in writing. In a variety of situations, arts students set down information as different as facts, ideas, opinions, and original creations. Assignments to keep notes on studio work (for example, to record color

experiments) or keep records (such as rehearsal notes or production books in theater classes) call forth efficient, pragmatic writing. The experience of evaluating works challenges students with the difficult task of supporting opinions and synthesizing interpretations. Some students may attempt to write a literary work such as a one-act play. In doing so, they develop ideas and explore structure and words as an artistic medium for expressing those ideas.

Several skills that underlie good writing are practiced and refined in the arts. One important constellation of skills involves conceiving ideas about a topic and then organizing, selecting, and relating them in a coherent way. In writing about the arts, students learn the importance of building convincing arguments and organizing many, often complex, ideas into paragraphs. The ability to select ideas and organize them into a coherent composition is also practiced when students create their own works in media other than discursive writing. It is essential, for example, in activities such as musical composition or film editing. And what students learn from their experiences in producing artworks is likely to improve their ability to organize and develop their ideas, select supportive details, and vary the style according to purpose and audience when they return to written forms in other classes or situations.

In preparing written work for arts classes, students practice the conventions of English usage. They may learn, for instance, that a convincing written statement about works of art requires complete sentences, appropriate use and spelling of words, proper punctuation, capitalization, possessives, plural forms, and other matters of mechanics. Proofreading of papers is an essential aspect of writing for arts classes. Students learn to look at their first efforts—research papers, works of criticism, or original plays—as drafts to be revised. This skill utilizes proofreading, restructuring, and redrafting techniques.

Another important writing skill is the ability to vary one's writing style, including vocabulary and sentence structure, for different readers and different purposes. In different sorts of assignments, such as a promotional piece to announce an upcoming performance or an evaluation of a peer's original work, students practice and improve this skill.

In order to develop historical and cultural knowledge about the

arts, students are likely to practice various writing skills that go with research—gathering information from primary and secondary sources, quoting, paraphrasing, summarizing, and citing sources properly.

Finally, as in the case of reading, working in the arts frequently requires that students learn new systems of "writing," using different sets of symbols and conventions. Musical composition, dance notation, and the recording of movement within a play all require that students learn additional ways to set down information. Experiences with these other forms of "writing" may sharpen students' awareness of the issues and challenges in creating accurate, useful records.

Speaking and Listening

As with all other classroom experiences, instruction in the arts involves lectures, question-and-answer periods, and discussions that require that students be able to engage in the oral exchange of ideas. In addition, study of the arts also puts students in new situations in which the impetus for refining listening and speaking skills is especially strong.

In particular, the disciplines of music, theater, and dance challenge students to develop close or intensive listening skills. In order to perform or understand a musical composition, students must be able to attend to melodic, rhythmic, and structural information simultaneously. Moreover, students must listen to one another and perfect the skill of integrating sequentially heard musical effects into an overall understanding of a piece. The activity is particularly challenging when students become audience members and listen without the benefit of written scores. In the case of theater instruction, participation in or attendance at productions can alert students to hearing aspects of oral language otherwise overlooked: pitch, accent, pause, and inflection. Speaking skills also receive intensive training in theater classes. The focus on speech as more than a means to the exchange of information serves to highlight many of the special qualities and powers of oral communication.

Another important skill that students of the arts can develop is

the ability to engage critically and constructively in the exchange of ideas, particularly during class discussions and conferences with instructors. They can learn how to carry on frank and critical discussions about their own work and that of their peers, as this is an important way for them to begin the process of editing and polishing works and performances in progress. The group critique in the visual arts is a common forum for this kind of exchange of ideas.

Speaking and listening also demand an ability to answer and ask questions coherently and concisely and to follow spoken instructions. In the arts, these skills are particularly crucial. In dance, incorrect understanding of instructions can result in physical harm. In the visual arts, accidents can result when students do not understand how to use tools (such as knives and kilns) properly. In music, dance, or theater the proper execution of ensemble work requires that everyone understands the instructions of the conductor, choreographer, or director.

Students in the arts sometimes have an opportunity to hear working artists and performers discussing their work either in radio or television interviews or in live lectures. These discussions are often extremely intense and detailed, and it is a particular challenge for students to sort out the main ideas, concepts, and theories from less essential ones.

Another teaching and learning device in arts classes is the presentation and discussion of works in progress. Students learn that they cannot rely on an unfinished work of art or a performance to "speak for itself," and that they must be able to explain clearly what choices they have made, how they made them, and what effects they were trying to achieve. It is important for students to learn how to make such presentations both to their peers and to their instructors. They must learn that speaking informally with fellow students about a work in progress requires speaking skills different from those needed in discussing it with the instructor or making a formal presentation about it to the class. Discussing one's own work requires skills different from discussing the work of peers or other artists. Students must learn to recognize the appropriate situations for using these varying forms of speech.

Mathematics

The practical aspects of the arts may rely on basic mathematical abilities. Both calculation and measurement are required in activities such as building scenery, mixing pigments, or using a photographic enlarger. Basic calculating and estimating skills are required in budgeting a theater or dance performance. Because these mathematical skills and those treated below are important for work in the arts, arts courses can provide motivation and practical applications valuable in developing such skills. However, while these and more complex links certainly exist between mathematical and artistic processes, even in-depth studies in the arts will provide only supplementary rather than substantial opportunities to practice basic mathematical competencies.

The visual arts require students to calculate proportions and divisions of space and to perform computations for such tasks as repetition of patterns in design and fiber calculations in weaving. Dance requires subdivisions of time and space. The study of rhythm in music requires computational facility. The building of scenery and the use of technical equipment in dance and theater often require students to use both customary and metric units in measurement, as do several media in the visual arts (photography, graphic design, and clay).

Many of the arts make use of basic mathematical operations. Musical rhythm requires facility with fractions, and the structure of phrases and sections involves the recognition of proportions. The visual arts require extensive use of geometry in developing forms and understanding perspective. An understanding of numerical patterns and sequences can be helpful in constructing and recording dance.

Another mathematical skill—the ability to make estimates and approximations—is also an element of student learning in the arts. Instrumentalists estimate the length of phrases in order to mark their parts for breathing and bowing purposes; choreographers and stage directors estimate the dimensions of a stage as they block a dance or a play; visual artists estimate size and scale as they attempt to sketch a visual image on paper or canvas. Learning how

to make these estimates quickly and accurately is one element of student learning in the arts.

Arts students often need to understand the mathematical aspects of artistic problems in order to solve them. Learning to draw a two-dimensional object on a grid, drawing in perspective, and reducing objects to geometric forms require an understanding of how to formulate an artistic problem in mathematical terms. Selecting and using the appropriate approaches to solving problems (mental computation, trial and error, paper-and-pencil techniques, and so on) is an important complementary skill. Whether the task is color mixing or designing three-dimensional spaces, students in the visual arts learn when it is appropriate to estimate, to calculate, or even, in some instances, to use a computer. The performing arts also offer opportunities to use different levels of mathematical problem solving. In learning to "cost" a show, for example, students can begin by "ball parking" a gross figure, then estimate a budget using round numbers for line items, and, finally, carefully calculate the exact cost of the show.

Reasoning

A competent reasoner is an individual with the ability to formulate and solve problems based on the thoughtful use of evidence and inference. While the content of problems in the arts may be distinct, artistic reasoning relies on some of the same abilities and procedures that are employed in other academic disciplines.

A basic element of the reasoning process is the ability to identify problems and to develop strategies to solve them. Making or performing a work of art has as its first step the formulation of an interesting or worthwhile problem. Choreographing a dance is a problem-solving process that examines alternative uses of time, space, movement, sound, and visual effects to create mood and meaning. Performing a musical composition requires the mapping out and solution of problems in the areas of tempo, phrasing, and dynamics.

Reasoning also involves a recognition of how and when to use inductive and deductive approaches to problem solving. In theater,

an inductive approach uses the material in the play script to provide clues for constructing action, developing character, choosing a cast, and costuming the show. A more deductive approach begins with a director's specific concept of the play in making these same choices.

Another important element of reasoning is the ability to draw reasonable conclusions from varying types of evidence. Arts students learn that a work of art provides one kind of evidence, written criticism another, and oral critiques still a third. An artist's or performer's concept of his or her own work may differ markedly from the critic's or the historian's. A student in visual arts may study a work of sculpture by viewing a two-dimensional photograph of it, hearing a lecture about it, seeing the original piece in a museum, viewing a scale model of it, trying to recreate the sculpture, and reading criticism about it.

Concepts and generalizations are aspects of reasoning that provide students with important ways to gain a better understanding of the arts. General concepts such as "style," "symmetry," or "tension" provide the intellectual tools for appreciating and discussing many art forms. Similarly, specific stylistic concepts such as "classical," "primitive," or "Romantic" provide a means for characterizing and comparing works of art. Furthermore, the arts can provide an important vehicle for separating fact from taste. As students develop their own critical faculties (and read the work of professional critics), they learn the importance of separating how one may feel about a work of art from what is actually observable in the work itself.

Studying

The ability to study is the ability to "learn how to learn." Artistic training provides many opportunities for the development of conventional study skills: the acquisition and use of specialized vocabulary; practice in following instructions; and the exercise of techniques such as reading, note taking, summarizing, and synthesizing. In addition to developing these familiar types of studying, arts courses can make several distinctive contributions to study skills.

Important areas for arts activity exist outside the classroom in

theaters, museums, and concert halls. In addition, television, radio, and recordings provide other primary sources of arts activity. Consequently, arts courses provide an opportunity for students to become skilled in locating and using resources external to schools. Since performances and exhibitions inevitably vary in quality, students have the opportunity to learn how to judge which are likely to be the most valuable and rewarding resources for study.

Because works of art are particularly rich in different levels and types of information, arts courses may help students learn about the benefits of *repeated* study. The first few readings of a musical piece may yield only an overview of its rhythmic and melodic content, while subsequent readings yield new insights into the finer details and expressive richness of the work. A play can be studied at different times for characterization, dialogue techniques, imagery and symbols, ideas and themes, and structure.

Students in the arts learn how to set study goals, to establish surroundings and habits conducive to learning independently or with others, and to follow a schedule that accounts for both short- and long-term projects. Performers must develop practice routines, locate appropriate spaces for daily work, and coordinate their schedules to allow for regular ensemble work with their peers. Visual arts students must plan time to allow for kiln firing, oil paints drying, or inks setting. The preparation of performances and visual art portfolios places a premium on long-term planning.

In addition, arts students as they study have the opportunity to develop and use general and specialized vocabularies, and to use them for a variety of purposes. Vibrato, pirouette, chiaroscuro, and fresnel, for example, are all technical terms that are utilized in high school arts programs. Developing a facility with this technical language and learning to expand their technical vocabulary by studying are essential, as students are more able to execute and analyze work in the art form when they understand its specialized terms.

Following instructions is also an important aspect of learning to learn. Students in the arts learn to use the customary kinds of instruction from teachers and books. In addition, they must learn to follow the specific forms of instruction unique to their art form. For example, band students learn how to follow a conductor, and theater students learn how to interpret the instructions of the director. Once students learn the principles behind these instruc-

tions, they can apply them in new situations. They begin to be able to follow the instructions of unfamiliar conductors, directors, choreographers, or painting instructors.

Some people believe that the arts do not offer sufficient opportunities for students to learn how to take examinations. However, the arts offer a variety of "tests" of learning. In addition to conventional school examinations, students in music, theater, and dance must undergo the rigors of performance "tests" and develop a variety of strategies for dealing with nervous tension, mistakes, memory slips, and the challenges of being part of an ensemble under pressure. Students in the visual arts learn how to prepare and present a portfolio and undergo group critiques of their work. Many students in the arts learn how to cope with the pressures of auditions, competitions, and a variety of other testing situations in and out of school.

Finally, in the arts, students learn the importance of constructive criticism as an important route to proficiency. The role of the teacher, the conductor, the choreographer, the director, and peers is to offer insights in viewing works in progress. Students must learn to accept and make use of this criticism. They must also learn how to offer it to others.

Other Basic Skills

In addition to the Basic Academic Competencies already described, *Academic Preparation for College* cited two others. The first of these was *observing,* which was discussed in an appendix; the second was *computer competency,* which was described as an "emerging need" for students going on to college. How arts courses can contribute to developing both of these competencies is described in the following pages.

Observing

Learning to observe is at the heart of arts education. If students are to develop individual styles and fresh interpretations, they must be alive to the unique and distinctive qualities of the objects in the natural, social, and artistic world around them. Visual arts students

given an assignment to draw an egg over and over again learn to observe the almost invisible details of the shell. Students writing for the stage may strive to see and capture the differences between the white of snow, cotton cloth, and milk. A student actor must be able to see the difference between embarrassment and shyness in order to convey each of these closely related emotions distinctly.

Working within an art form teaches a range of different types of observational skills. Detailed observation is required to monitor moment-to-moment activities: the way the hand moves a chisel on the block, the placement of the bow on the strings, the intensity of stage lighting. But at a different level artworks challenge students to observe more conceptually and never to be satisfied that they have seen or heard everything that a work of art contains. Sonatas, dances, and paintings are all "thick" with meaning, and a skilled observer is likely to discover some additional meaning or nuance with each encounter. Rehearsing, re-reading, or looking again at a work of art helps students to see both distinctive features and the broad general patterns that it exemplifies.

Students in the visual arts learn to recognize and interpret different forms of visual materials and learn to produce such forms in their own work. They come to realize that a cartoon, a diagram, a graph, an illustration, a model, a painting, or any other visual display conveys a special kind of meaning and feeling. Such sensitivity to different forms of symbolic material is developed in the other art forms as well, giving students a heightened ability to observe and interpret what they see, hear, feel, and touch in the world around them.

Computer Competency

People sometimes assume that there is an antagonism between the arts and technology. The fact is that the arts have often utilized new technologies to develop important tools such as the printing press, the movie camera, or the synthesizer. Technological advances have often infused the arts with new expressive possibilities—as with photography in the visual arts. Partnerships between the arts and computer sciences are *potentially* as promising. If computer science students are challenged to generate images, texts, or sounds that are artistically worthwhile, they can apply

their existing programming skills in novel ways, invent new types of programs, consider the quality and diversity of what their programs produce, and investigate how their creation affects an audience.

In addition, computers can assist arts students to carry out tasks more effectively and more quickly. Microcomputers offer students of scene design, composition, choreography, and the visual arts tools for composing and editing that make repeated changes quick and easy. The flexibility and efficiency of such electronic editing can be used to encourage students to take risks and to refine their work. Similarly, the computer's ability to transform information into different types of displays offers students the unusual opportunity to vary the color, size, speed, and format of their compositions. Given the facility and efficiency of computer arts, the hidden challenge for teachers is to be genuinely imaginative and expressive in finding ways to utilize this remarkable new technology.

Conclusion

It is sometimes argued that while the arts are important, they do not deserve a prominent place in the high school curriculum because the limited number of teaching hours should be reserved for "the basic skills." The purpose of this chapter has been to show that *work in the arts involves such basic skills*. The chapter has carefully examined the list of Basic Academic Competencies on which many fields of learning depend and has indicated how the arts contribute to developing them. High school teachers of the arts can help their students improve these fundamental academic skills while doing work in their particular art form.

VI. Toward Further Discussion

This last chapter brings to light two kinds of outstanding issues in arts education. The first set of issues includes those that arts teachers often discuss with each other—questions concerning the best ways to achieve excellence for all students in arts education. The second set focuses on the problems of winning and maintaining a place for high-quality arts education within the high school curriculum. By identifying some of these issues we hope to stimulate further dialogue among arts teachers and those who work with them. Such discussion seems a needed next step toward improving the academic preparation of all students for college.

How to Achieve Excellence

Within any discipline there are debates about how best to achieve excellence. In arts education the discussion often returns to the following issues.

Moving beyond Production and Performance

Many arts programs focus on the production aspects of the arts—performing a dance or a band piece, acting in a play, painting, or sculpting. It is much rarer that high school students have the opportunity to learn in depth about the theater, dance, music, or visual arts of other periods and cultures. Also infrequent is instruction in the critical skills—learning how to analyze and evaluate works and performances. However, as indicated in Chapter 2, it is important that students learn more than production and performance. A major challenge for arts teachers is to widen, and consequently deepen, the traditional focus of arts instruction.

Whose Arts?

The bulk of arts teaching in high schools focuses on the arts of western Europe and the United States—even though Central and

South American, African, and Asian cultures have significant artistic traditions. Moreover, the theater, dance, visual arts, and music of minority American cultures rarely receive concentrated study. Similarly, the artistic achievements of women artists are seldom studied. The typical and relatively narrow definition of "art" threatens excellence in arts instruction in two ways. First, all students are presented with a restricted view of the styles, themes, and techniques belonging to world culture. Consequently, their understanding of the arts is less complex and varied than it should be. Second, students belonging to ignored groups are not encouraged to see that people like themselves have made and can continue to make major contributions to the arts.

Assessment

It is difficult to imagine disciplines in which the problem of assessment is more challenging than in the arts. There are several reasons for this.

- First, the criteria for "doing well" in production and performance, criticism, and historical analysis are all different. A student may be a highly skilled dancer but may not yet have developed the speaking and writing skills needed to engage successfully in analysis or evaluation. Another student may be quite articulate verbally but lack basic pitch-matching abilities. And within the domain of production and performance, the criteria for assessing musical composition differ from those for sculpture, animated film, poem, monologue, or dance.

- Second, the arts emphasize individual expression and innovation. Thus, teachers are constantly faced with the problem of evaluating new performances and works for which there are no pre-established standards. One student may bravely explore a new medium with originality but with uneven artistic results, while another student may skillfully execute a work in a familiar medium that looks much like the other pieces that he or she has already produced. How is a teacher to make objective evaluations of the two students and translate these into grades? Arts teachers constantly face the challenge of making evaluations that do not

confuse the assessment of skill and achievement with matters of personal taste or preference.

- Third, developing quizzes, tests, and examinations in the arts is difficult. Facts about the arts constitute only a portion of the material on which artistic competency is based. Aesthetic skills tend to be conceptual or performance-oriented, and demonstration of competency is not always best achieved in a formal examination.

Despite these challenges, arts teachers have to deal with the fact that assessments are an important tool for helping students to see when work in the arts is successful. Moreover, high schools that regard the arts as Basic Academic Subjects expect their arts teachers to develop objective assessment procedures in the courses that translate into numerical scores and grades. Many teachers have already met this challenge; others have not. For some years the College Board has used standardized testing procedures—the Advanced Placement Examinations—to assess the progress of students in advanced placement courses in music and art. While these tests meet the challenge for assessment at only one level, they do provide a model that can be discussed and perhaps extended. New and more varied approaches are likely to emerge if arts teachers share what they know about assessment and actively seek to learn from one another.

Breadth versus Depth

Given limited resources, it is frequently difficult for high schools to continue to offer courses in music, visual arts, dance, and theater. When forced to cut back, arts faculties have come up with several solutions: general arts courses that survey a number of forms, a pattern of alternating courses across years, and decisions to concentrate in single disciplines within individual schools. Not surprisingly, there is considerable debate about which of these solutions is best. Some educators argue for a breadth of exposure through general arts courses, reasoning that college is the place for concentration. Others recommend an in-depth approach, arguing that without focus students have no chance to learn the particular skills associated with aesthetic thinking.

As with so many questions of educational philosophy, this one has no single right answer. However, earlier chapters have suggested that there is a minimum amount of material that must be covered in one of the arts if it is genuinely to function as a Basic Academic Subject. To develop productive proficiency; to learn about the history of an art form; to be able to identify important works or styles; and to develop the ability to analyze, interpret, and evaluate require a good deal of training and experience. Certainly, at least a year of in-depth study in one of the arts subjects is necessary.

The Arts and Other Subjects

The arts, if properly taught, can develop basic skills, as has been indicated in this book. In addition, the arts offer numerous opportunities to forge links to other basic subjects in the high school curriculum. Arts teachers can begin to discuss and develop particular units with teachers of other subjects. A unit on color or sound can be taught in conjunction with work in a science class; a performance of a Bach chorale can use a translation produced in a German class; a production of Arthur Miller's play *The Crucible* can be enhanced by studying the Salem witch trials in an American history class. The arts are well suited to connections of this kind, and the efforts of school administrators who provide extra planning time for their teachers for joint activities and curricula are often well rewarded. It is perhaps particularly important for arts teachers, who have worked in comparative isolation from other teachers, to consider such efforts.

However, making connections between the arts and other subjects is one kind of activity; using the arts in teaching other subjects is quite another. When, for example, a history teacher spends a couple of days teaching the art of Greece in a month-long unit about the ancient world, she is using the arts to teach an aspect of history, but her purpose is not to provide students with learning experiences *in the arts*. We can applaud her insight in developing an approach to history that includes the arts, but we must be sure that the school community understands that this activity is quite different from a fully developed arts course. In this limited approach the

teacher offers no studio training; she does not develop students' analytic abilities with respect to examining these works of art (except as historical artifacts); she does not offer analogous works from other cultures for comparison; and, perhaps most important, she does not have the time to provide the kind of *aesthetic* perspective and overview that makes studying the arts different from studying any other subject.

The distinction between studying the arts and using information from the arts to inform other subject areas is a crucial one. The arts provide their own subject matter, which must be mastered through continuous study. As with any other subject, there is a threshold of instructional time below which students are not able to learn the necessary subject matter.

The Use of Outside Artists and Arts Organizations

Observing, studying, and reacting to the work of professional artists—not just works on tape, records, and slides, but original art works and performances—is a valuable experience for arts students. Consequently, effective secondary-school programs in the arts are enhanced when teachers find ways to build into the curriculum collaborations with arts institutions such as theaters, museums, dance troupes, and chamber music groups. In addition, visits to the school by artists and performers are more common in recent years, and these can also be very beneficial in enriching students' educational experiences.

Planning and implementing these collaborations are not easy. They generally involve some added expenses and considerable administrative and logistical demands, which can be especially difficult for schools located far from urban areas. Sometimes these schools must use lending libraries or touring companies, or draw on artist-in-residence programs sponsored by state arts councils. In addition, finding and choosing the right outside artistic resources can be the most challenging part of the process. A dancer may be a superb performer, an actor may have appeared in many plays, but often artists have little or no pedagogical training, and if they do not know how to work effectively with high school students their time with students can be largely wasted. Similarly, just because a

museum has a fine collection or an orchestra has gone on several world tours does not mean that a field trip will necessarily provide a rich educational experience for the students.

Students must be prepared for field trips and have the chance afterward to reflect on the concerts, plays, or exhibits they have attended. Visiting professional artists can work with students in a medium or at a level of sophistication not usually available; as adults who have pursued the arts as a career, they will also serve as role models to the students. However, the short tenure of visiting artists and their focus on their own professional work will mean that their contributions to student development are supplementary to, not replacements for, the longer-term educational skills of classroom instructors.

Issues beyond the Arts Classroom

Arts instruction goes on in self-contained theaters, classrooms, and studios. However, what high school students learn about the arts is also affected by what goes on outside these settings. The larger community profoundly influences the climate of learning and, ultimately, the effectiveness of a particular teacher or arts curriculum. The attitudes of administrators in schools determine whether their institutions support arts programs and allocate sufficient resources to allow them to succeed. A realistic agenda for discussion and debate must look beyond curricula and teaching and raise questions that arise from community and school settings and from educators in other subjects.

Seeing Arts Courses as Basic

In a 1983 *Gallup Poll of the Public's Attitudes toward the Public Schools*, pollsters asked people which high school subjects they would require of every high school student who planned to go on to college. Not surprisingly, mathematics was at the top of the list: 92 percent of those surveyed said that it should be required. English (88 percent), history or government (78 percent), and science (76 percent) followed. Art (19 percent) and music (18 percent) were at

the bottom, ranking tenth and eleventh in the list of subjects. Clearly, the people polled did not appreciate the fact that the arts can make significant contributions to students' knowledge and skills.

People who believe that art is a matter of raw talent sometimes argue that gifted students should be encouraged but that the arts should not be required of students who "have no talent." They hold that these so-called normal students should be given an opportunity to develop skills in other areas in which they have demonstrated natural proficiency. What this argument does not recognize, of course, is that classes in the arts are not intended primarily to train professional artists and performers but to help all students develop an awareness and understanding of the arts. Just as all students do not need to exhibit a special aptitude for mathematics in order to be required to study it, so they should not need to demonstrate special talent in the arts in order to be required to take courses in them.

Overcoming the Vulnerability of Arts Programs

When the arts mistakenly are considered frills, arts programs can be vulnerable to cutbacks or elimination. Even where programs are sustained, they inadvertently can be given a kind of second-class status within the high school curriculum. It is important for high school administrators and others outside the classroom to be aware of the following issues in order to set appropriately high standards for arts programs.

- *Sequential Training.* In many school systems the need for a coherent arts program going from the first grade through the twelfth has not yet been addressed. Because of scheduling problems, high school arts departments often must offer either courses that can be taken in any order or courses that are tied to a student's grade level (for example, tenth-grade visual arts, senior music). Students may take this practice as a signal that the arts, unlike foreign languages or sciences, are not disciplines demanding skills or previous training. Such patterns of course assignment are damaging to the education of all students, not just those who might become professional artists.

■ *Counseling.* Doubts about the worth of artistic training can be evident in patterns of counseling students. Many counselors have not thought about which arts courses would be best for which students, and some let students make their own choices for reasons that are sometimes spurious—such as convenient scheduling or their friends' courses. In some schools, arts classes are regarded as recreational or therapeutic, with the result that many low-achieving, disturbed, or learning-disabled students are channeled into studio and performance classes. Conversely, high-achieving students may be encouraged to enroll in "more demanding" classes in mathematics, history, or the sciences. Clearly, such patterns of advice make arts classes into what one teacher has termed a "holding tank" that does not serve well the needs of either high- or low-achieving students.

The problem is not limited to high schools. Many high school counselors say that their patterns of advice are based on what they learn from college admissions offices and students who go on to postsecondary education. If the arts are to be taken seriously, colleges must regard arts courses in the same light as enrollment in other courses. And college arts teachers, no less than college biology teachers, should design their courses in a way that recognizes that their students should have already done work in their area and develop strategies for coping with disparities in the quality of students' preparation. As high school counselors learn that college teachers are changing and have changed in this way, the guidance they give students may also change.

It is also important for guidance counselors to be aware of the special needs of committed arts students who may feel forced to choose between continuing in high school and going on to early professional training. Otherwise, students and families are on their own in balancing the importance of completing high school against the possible gains of earlier in-depth training. Students who are committed to the arts also need reliable information about colleges and universities with strong departments in the arts and about good conservatories and art schools.

■ *Notice and Reward.* In order to thrive within a high school, it is critical that the arts be recognized and appreciated in ways that parallel other areas of student achievement. Exhibits of student

work might be displayed in the front hall, not just the art room. Plays and dance performances might be open to students from other schools and community groups. Schools that give prizes should consider making arts awards along with other kinds of prizes. Furthermore, arts teachers who are helping individuals or groups of students prepare for showcases, competitions, or exhibitions can be more effective if they have the help of other faculty and the principal. Committed arts students should have help in finding ways to combine additional training with their high school programs.

Put four teachers in the same room—one each from the fields of mathematics, history, English, and arts—and there will be four voices, each explaining why his or her particular subject is "special." Each can list a dozen reasons for allocating more staff, materials, and dollars to that discipline. But the hard fact is that time, space, and money in a high school are all limited.

Though it is impossible to prove that the arts are the most deserving recipients of the school's resources, it should be pointed out that the arts do have special needs and that ignoring them hurts the quality of instruction. In many schools arts teachers need to invest more time than they have before in clarifying to their colleagues, as well as administrators, the nature and goals of their work and the sort of scheduling, space, equipment, and materials necessary to meet their objectives.

■ *The Arts in the Schedule.* Rehearsals, museum visits, and other classes cannot always be effectively squeezed into the 40- or 50-minute blocks used for other academic classes. By the time dancers have warmed up or visual arts students have prepared their materials, a large portion of class time is gone. Clearly, double periods, supplementary after-school slots, or special arts days in the school week can be more effective than restricting some arts classes to single periods.

Additional schedule flexibility is required to accommodate a field trip to a museum, a gallery, a concert hall, or a theater. School administrators and other teachers may agree that viewing original works of art and attending live performances is an important component of arts learning, but it is difficult for them to be enthusiastic about such activities when they compete with

mathematics tests, English classes, or athletic events. It is important that arts teachers recognize candidly that their activities can be experienced as disruptive by other teachers. Arts teachers must often persuade their colleagues who teach other subjects that a trip might serve both their needs. A joint assignment around the art of medieval Europe might be developed with a social studies teacher in conjunction with a visit to a museum. A field trip to a theater might serve the needs of both an English teacher and a theater instructor.

■ *Space, Equipment, and Materials for the Arts.* Not every high school can provide the kind of facilities that are best suited to artistic training: wooden dance floors, audio equipment for dancing, on-site kilns, practice rooms, exhibit space, and a theater with lighting equipment. Arts teachers learn to make do with the space and equipment that is provided. But it is important for the school community to recognize that inadequate facilities may provide an additional obstacle to designing an effective arts program.

Often, when school budgets are trimmed, arts teachers find themselves forced to cut down on the amount and the quality of the materials they use. The decision on the part of school administrators to make across-the-board cuts in the budgets of all programs, or to make particularly deep cuts for arts classes, does not recognize the special need for materials in studio work, quality instruments for bands and orchestras, or costumes and lighting equipment for theater performances. Teachers can help to raise money for special supplies, but if the arts are a part of the core curriculum, there must be enough financial support from the school budget to provide adequate materials.

It makes little sense, for example, for a school to offer a photography class if students are not provided with an adequate supply of film, papers, and developing solutions. Without a variety of these materials on hand, students will never learn to create photographs with subtle variations in tone and effect. Many skilled teachers manage under less than optimal circumstances, but it is wearing and distracting to have to scrounge and skimp.

Conclusion

This chapter has raised issues that are addressed by many people currently involved in arts education. These issues deserve wider discussion. The ways in which they are resolved can affect significantly the quality of students' and teachers' achievements in the arts. Over the years, despite sometimes meager resources, teachers have found ways to work around institutional obstacles and offer outstanding arts courses to generations of high school students. But it is important to remember that if the arts are to be taught with depth and insight, teachers must have a climate of encouragement and support—an environment in which colleagues, administrators, parents, and friends applaud their achievements and respect the value of the subject matter they teach.

Bibliography

Teachers can use the following resources as they plan and carry out courses in the arts. The selections are meant simply as suggestions. The members of the Arts Advisory Committee do not intend the following list to be prescriptive; instead, these suggestions are more nearly a listing of personal favorites.

Some of the following resources will assist teachers in broadening a course to include all three elements of arts learning and experience: historical; analytical and evaluative; and productive or performing. Others will help teachers include more material concerning the contributions of various cultures or ethnic groups to the arts, and what art indicates about the group that produced it.

These resources may serve to complement other resources a teacher has, or they may be the starting point from which a teacher can locate even more resources. The professional organizations of teachers of each arts discipline can provide much more detailed information about additional resources.

Visual Arts

Albers, Josef. *The Interaction of Color*, revised ed. New Haven: Yale University Press, 1975.

Bearden, Romare, and Carroll Green. *The Evolution of Afro-American Artists: 1800-1950*. New York: City University, 1967.

Cambell, Mary. *Tradition and Conflict: Images of a Turbulent Decade, 1963-1973*. New York: Studio Museum in Harlem, 1984. This catalog documents an important exhibit exploring the philosophy of black artists of one decade.

Chipp, Herschel B. *Theories of Modern Art: A Source Book by Artists and Critics*. Berkeley: University of California Press, 1980.

Collier, Graham. *Form, Space, and Vision*, 3rd ed. Englewood Cliffs, New Jersey: Prentice-Hall, 1972.

Davis, Lenwood G., and Janet L. Sims. *Black Artists in the United States: An Annotated Bibliography of Books, Articles, and Dissertations on Black Artists, 1779-1979*. Westport, Connecticut: Greenwood Press, 1980.

Dover, Cedric. *American Negro Art*. Greenwich, Connecticut: New York Graphic Society, 1966.

Gardner, Helen. *Art through the Ages*, 7th ed. New York: Harcourt Brace Jovanovich, 1980. Also *Study Guide for Gardner's "Art through the Ages,"* by Kathleen Cohen and Horst de la Croix, New York: Harcourt Brace Jovanovich, 1980.

Harris, Ann S., and Linda Nochlin. *Women Artists, 1550-1950*. New York: Random House, 1976.

Hartt, Frederick. *Art: A History of Painting, Sculpture, Architecture*, 2 vols. Englewood Cliffs, New Jersey: Prentice-Hall, 1976.

Hurwitz, Al, and Stanley Madeja. *The Joyous Vision: A Sourcebook for Elementary Art Appreciation*. Englewood Cliffs, New Jersey: Prentice-Hall, 1977.

Igoe, Lynn Moody, and James Igoe. *250 Years of Afro-American Art: An Annotated Bibliography*. New York: R.R. Bowker Co., 1981.

Itten, Johannes. *The Art of Color*. New York: Van Nostrand Reinhold, 1973.

Janson, Horst Woldemar. *History of Art*, rev. ed. Englewood Cliffs, New Jersey: Prentice-Hall, 1981.

Kaupelis, Robert. *Experimental Drawing Techniques*. New York: Watson-Guptill Publications, 1980.

————. *Learning to Draw*. New York: Watson-Guptill Publications, 1966.

Lewis, Samella, and Ruth Waddy. *Black Artists on Art*. Los Angeles: Contemporary Crafts, Inc., vol. 1, 1969; vol. 2, 1971.

Lipman, Jean, and Alice Winchester. *The Flowering of American Folk Art, 1776-1876*. New York: Viking Press with Whitney Museum of Art, 1974.

Locke, Alain LeRoy. *The Negro in Art*. New York: Hacker Art Books, 1971.

Maier, Manfred. *Basic Principles of Design*, 4 vols. New York: Van Nostrand Reinhold, 1977.

Newton, James E., and Ronald L. Lewis (eds.). *The Other Slaves: Mechanics, Artisans, and Craftsmen*. Boston: G.K. Hall & Co., 1978.

Porter, James A. *The Negro in American Art*. Los Angeles: California Arts Commission, 1966.

Quirarte, Jacinto. *Mexican American Artists*. Austin: University of Texas Press, 1973.

Simpson, Ian. *Drawing: Seeing and Observation*. New York: Van Nostrand Reinhold, 1981.

Van Sertima, Ivan. *They Came before Columbus: The African Presence in Ancient America*. New York: Random House, 1976.

Wuthenau, Alexander von. *The Art of Terracotta Pottery in Pre-Columbian Central and South America*. New York: Crown, 1970.

Theater

Aristotle. *The Poetics*, trans. by Samuel Henry Butcher. New York: Dover Publications, 1951. Aristotle's theory of poetry and fine art, with a critical text and translation of the poetics. Introduction by John Gassner.

Barton, Lucy. *Historic Costume for the Stage*. Boston: Baker Co., 1963.

Bentley, Eric. *The Life of the Drama*. New York: Atheneum, 1964.

Bowers, Faubion. *Theater in the East*. New York: T. Nelson, 1956.

Brandon, James R. *Theatre in Southeast Asia*. Cambridge: Harvard University Press, 1974.

Brockett, Oscar. *History of the Theatre*. Newton, Massachusetts: Allyn & Bacon, 1981.

———. *The Theatre: An Introduction*, 4th ed. New York: Holt, Rinehart & Winston, 1979.

Clurman, Harold. *On Directing*. New York: Macmillan, 1974.

Cole, Toby (ed.). *Playwrights on Playwrighting: The Meaning and Making of Modern Drama*. New York: Hill & Wang, 1961.

Cole, Toby, and Helen Chinoy (eds.). *Actors on Acting*. New York: Crown, 1980.

———. *Directors on Directing*. New York: Bobbs Merrill, 1963.

Course Guide for Secondary School Theatre, A. Washington, D.C.: Secondary School Theatre Association of the American Theatre Association, 1975.

Goldberg, Moses. *Children's Theatre: A Philosophy and a Method*. Englewood Cliffs, New Jersey: Prentice-Hall, 1973.

Goodman, Randolph. *Drama on Stage*. New York: Holt, Rinehart & Winston, 1978.

Hagen, Uta, and Haskel Frankel. *Respect for Acting*. New York: Macmillan, 1973.

Haskins, James. *Black Theatre in America*. New York: Harper & Row, 1982.

Hatch, James, and Ted Shine (eds.). *Black Theatre, U.S.A.: 45 Plays by Black Americans, 1847-1974*. New York: Free Press, 1974.

Hoggett, Chris. *Stage Crafts*. New York: St. Martin's Press, 1977.

Jones, Robert Edmond. *Dramatic Imagination*. New York: Theatre Arts Books, 1941.

Lessac, Arthur. *The Use and Training of the Human Voice: A Practical Approach to Speech and Voice Dynamics*. New York: Drama Book Publishers, 1967.

McGregor, Lynn, Maggie Tate, and Ken Robinson. *Learning through Drama;* Schools Council Drama Teaching Project. Portsmouth, New Hampshire: Heinemann Educational Books, 1977.

Moore, Sonia. *Stanislavski System: The Professional Training of an Actor*, 2nd rev. ed. New York: Penguin, 1984.

Parker, Oren W., and Harvey K. Smith. *Scene Design and Stage Lighting*, 4th ed. New York: Holt, Rinehart & Winston, 1979.

Pecktal, Lynn. *Design and Painting for the Theatre*. New York: Holt, Rinehart & Winston, 1975.

Robinson, Ken (ed.). *Exploring Theatre and Education*. Portsmouth, New Hampshire: Heinemann Educational Books, 1980.

Shurtleff, Michael. *Audition*. New York: Bantam, 1980.

Spolin, Viola. *Improvisation for the Theatre: A Handbook of Teaching and Directing Techniques*. Evanston, Illinois: Northwestern University Press, 1983.

An additional resource for copies of published plays and books on many aspects of theater is the Drama Bookshop, 723 Seventh Avenue, New York, New York 10036.

Music

Bamberger, Jeanne S., and Howard Brofsky. *The Art of Listening: Developing Musical Perception*, 4th ed. New York: Harper & Row, 1979.

Benward, Bruce. *Music in Theory and Practice*, 2 vols. Dubuque, Iowa: William C. Brown Co., 1977.

Curriculum Guide. Published for American School Band Directors Association. Pittsburgh, Pennsylvania: Volkwein, 1973.

Decker, Harold A., and Julius Herford (eds.). *Choral Conductor: A Symposium*. Norwalk, Connecticut: Appleton-Century-Crofts, 1973.

de Lerma, Dominique-Rene (ed.). *Bibliography of Black Music*. vol. 1, *Reference Materials*; vol. 2, *Afro-American Idioms*. Westport, Connecticut: Greenwood Encyclopedia of Black Music Services, 1981.

Finn, William J. *Art of the Choral Conductor*, 2 vols. Princeton, New Jersey: Summy-Birchard Music, 1939; reprinted 1978.

Floyd, Samuel A., Jr., and Marsha J. Reisser (eds.). *Black Music in the United States: An Annotated Bibliography of Selected Reference and Research Materials*. Millwood, New York: Kraus International, 1983.

Green, Elizabeth A. *The Modern Conductor*, 3rd ed. Englewood Cliffs, New Jersey: Prentice-Hall, 1981.

Harder, Paul. *Basic Materials in Music Theory: A Programmed Course*, 5th ed., 2 vols. Newton, Massachusetts: Allyn & Bacon, 1981.

Herndon, Marcia, and Norma McLeod. *Music as Culture*. Norwood, Pennsylvania: Norwood Editions, 1980.

Hunsberger, Donald, and Roy Ernst. *The Art of Conducting.* New York: Knopf, 1983.

Kamien, Roger. *Music: An Appreciation,* 3rd ed. New York: McGraw-Hill, 1984.

Kerman, Joseph. *Listen,* 3rd ed. New York: Worth, 1980.

Lamb, Norman. *Guide to Teaching Strings,* 4th ed. Dubuque, Iowa: William C. Brown Co., 1983.

McBeth, W. Francis. *Effective Performance of Band Music.* San Antonio, Texas: Southern Music Company, 1972.

May, Elizabeth (ed.). *Musics of Many Cultures: An Introduction.* Berkeley: University of California Press, 1982.

Murphy, Howard A., Robert H. Melcher, and Willard F. Warch. *Music for Study.* Englewood Cliffs, New Jersey: Prentice-Hall, 1973.

Politoske, Daniel T. *Music,* 3rd ed. Englewood Cliffs, New Jersey: Prentice-Hall, 1984.

Roberts, John Storm. *Black Music of Two Worlds.* New York: William Morrow, 1974.

Robinson, Ray, and Allen Winold. *The Choral Experience: Literature, Materials, and Methods.* New York: Harper & Row, 1976.

Rublowsky, John. *Black Music in America.* New York: Basic Books, 1971.

Sachs, Curt. *The Wellsprings of Music.* New York: Da Capo Press, Inc., 1977.

Southern, Eileen. *Biographical Dictionary of Afro-American and African Musicians.* Westport, Connecticut: Greenwood Press, 1982.

Titton, Jeff Todd, et al. *Worlds of Music: An Introduction to the Music of the World's Peoples.* New York: Schirmer Books, 1984.

Wennerstrom, Mary. *Anthology of Musical Structure and Style.* Englewood Cliffs, New Jersey: Prentice-Hall, 1983.

Dance

Armstrong, Leslie, and Roger Morgan. *Space for Dance: An Architectural Design Guide,* ed. by Mike Lipske. New York: Publishing Center for Cultural Resources, 1984. 625 Broadway, New York, New York 10012.

Ballet News, 1865 Broadway, New York, New York 10023.

Cohen, Selma Jeanne (ed.). *Dance as a Theatre Art: Source Readings in Dance History from 1581 to the Present.* New York: Harper & Row, 1974.

Dance Magazine: College Guide, 1985-86. Dance Magazine, Inc., 33 W. 60th Street, New York, New York 10023.

Dance Magazine, Inc., 33 W. 60th Street, New York, New York 10023.

Dance Teacher Now, University Mall, Suite 2, 803 Russell Boulevard, Davis, California 95616.

DuPont, Betty (ed.). *Dance: The Art of Production*. St. Louis, Missouri: C. V. Mosby, 1977.

Mueller, John. *Dance Film Directory: An Annotated and Evaluative Guide to Films on Ballet and Modern Dance*. Princeton Book Co., 1979. P.O. Box 109, Princeton, New Jersey 08540.

VRI, The VRI Slide Library of Dance History. Volume I, *Survey: Dance History from Primitive Times to 1900* (1976). Volume II, *Dance: The Last Hundred Years* (1983). VRI, P.O. Box 128, Imperial Beach, California 92032.

Vincent, Larry M., M.D. *The Dancer's Book of Health*. Kansas City, Missouri: Andrews McMeel Parker, Inc., 1978.

Members of the Council on Academic Affairs, 1983-85

Peter N. Stearns, Heinz Professor of History, Carnegie-Mellon University, Pittsburgh, Pennsylvania (*Chair* 1983-85)

Dorothy S. Strong, Director of Mathematics, Chicago Public Schools, Illinois (*Vice Chair* 1983-85)

Victoria A. Arroyo, College Board Student Representative, Emory University, Atlanta, Georgia (1983-84)

Ida S. Baker, Principal, Cape Coral High School, Florida (1984-85)

Michael Anthony Brown, College Board Student Representative, University of Texas, Austin (1983-85)

Jean-Pierre Cauvin, Associate Professor of French, Department of French and Italian, University of Texas, Austin (1983-84)

Alice C. Cox, Assistant Vice President, Student Academic Services, Office of the President, University of California (1983-84, Trustee Liaison 1984-85)

Charles M. Dorn, Professor of Art and Design, Department of Creative Arts, Purdue University, West Lafayette, Indiana (1983-84)

Sidney H. Estes, Assistant Superintendent, Instructional Planning and Development, Atlanta Public Schools, Georgia (1983-85)

David B. Greene, Chairman, Division of Humanities, Wabash College, Crawfordsville, Indiana (1984-85)

Jan A. Guffin, Chairman, Department of English, North Central High School, Indianapolis, Indiana (1983-85)

John W. Kenelly, Professor of Mathematical Sciences, Clemson University, South Carolina (1983-85)

Mary E. Kesler, Assistant Headmistress, The Hockaday School, Dallas, Texas (Trustee Liaison 1983-85)

Arthur E. Levine, President, Bradford College, Massachusetts (1983-85)

Deirdre A. Ling, Vice Chancellor for University Relations and Development, University of Massachusetts, Amherst (Trustee Liaison 1983-84)

Judith A. Lozano-Loredo, Superintendent, Southside Independent School District, San Antonio, Texas (1983-84)

Eleanor M. McMahon, Commissioner of Higher Education, Rhode Island Office of Higher Education, Providence (1984-85)

Jacqueline Florance Meadows, Instructor of Social Science, North Carolina School of Science and Mathematics, Durham (1983-84)

Michael J. Mendelsohn, Professor of English, University of Tampa, Florida (1983-84)

Fay D. Metcalf, History Coordinator/Teacher, Boulder High School, Colorado (1983-85)

Vivian Rivera, College Board Student Representative, Adlai E. Stevenson High School, Bronx, New York (1984-85)

Raul S. Rodriguez, Chair, Language Department, Xaverian High School, Brooklyn, New York (1984-85)

Michael A. Saltman, Chairman, Science Department, Bronxville School, New York (1983-85)

Vivian H. T. Tom, Social Studies Teacher, Lincoln High School, Yonkers, New York (Trustee Liaison 1983-84)

Kenneth S. Washington, Vice Chancellor for Educational Services, Los Angeles Community College District, California (1983-85)

Henrietta V. Whiteman, Director/Professor, Native American Studies, University of Montana, Missoula (1984-85)

Roberto Zamora, Deputy Executive Director, Region One Education Service Center, Edinburg, Texas (1984-85)